On Loos, Ornament and Crime

COLUMNS OF SMOKE / VOL. II

Juan José Lahuerta

Translated by Graham Thomson

TENOV BOOKS

First published in Spanish in *Humaredas. Arquitectura, ornamentación, medios impresos.* Lampreave 2010.

Revised edition published in September 2015.

© of the text: Juan José Lahuerta
© of the translation: Graham Thomson
© of the images: their authors (See detailed list p. 122)
© of this edition:
Editorial Tenov
Casp 147
08013 Barcelona
tenov@editorialtenov.com
www.tenovbooks.com

Design by TENOV and Hector Aspano
Printed in Norprint, Barcelona

ISBN: 978-84-939231-5-0
DL: B-17902-2015

CONTENTS

'Even the most careful selection of the best may result in nothing if the worst are not eliminated without mercy [...] The proclamation of social elimination should be one of the supreme characteristics of all ethics, elevating to an ideal the end that the theory of evolution has demonstrated [...] Zarathustra exclaims: do not forgive your neighbour! For the people of today even that must be transcended. But in order that it may be transcended, the worst, the low, **the superfluous** must be slaughtered'.

Alexander Tille
Von Darwin bis Nietzsche: ein Buch Entwicklungsethik
(From Darwin to Nietzsche: a book of development ethics), 1895.
[J. J. Lahuerta's emphasis].

ON LOOS, ORNAMENT AND CRIME

In 1897, newspapers such as *Die Zeit, Die Wage* or *Neue Freie Presse* [fig. 1]—one of the most influential German-language dailies, with a circulation of around 50,000 at the turn of the century—began to publish topical articles by Loos on architecture, interior design, furniture, food, fashion, etiquette: on everything, in short, that he was soon to call 'the other', with the declared intention of 'introducing Western culture into Austria'.[1] In a city of great polemicists, dominated by a tragic ironic *vis*, Loos triumphed. But the Loos that triumphed then, with those articles, was not exactly the same Loos whom the history of modern architecture claims as one of its great theorists. The virulent disputes Loos engaged in with the politicians and administrators of that *fin de siècle* Vienna, and with his fellow citizens, and the invectives he launched against his fellow architects are certainly magnificent, but would perhaps not have assumed such historical prominence without the light subsequently cast on them by the articles he wrote late in the first decade of the twentieth century, and especially by the success—international and enduring, sustained over time—of 'Ornament und Verbrechen'[2] (Ornament and Crime), one of the most famous and most quoted texts in the history of modern architecture and modern culture, which many see—and saw at the start of the twentieth century—as the foundation stone of one of its essential ideological and formal features: the commitment to *disornamentation*.

In fact, in those early articles Loos focused—pertinently, in keeping with his aims—on local issues: the situation of the Museum of Applied Arts in Vienna (where he expended a great deal of energy in defence of its director, Arthur von Scala), an exhibition, a competition... but from the point of view of his future significance this would not be the most important limitation.

Wiener Jubiläums-Ausstellung.

Die Ausstellungsstadt.

Der neue Styl.

Ueber Nacht ist er gekommen. Ein ganzes Jahrhundert haben unsere Baukünstler mit der widerspenstigen Zeit gerungen, ein ganzes Jahrhundert hat man versucht, durch einen originellen Baustyle unserer Zeit den zeitgenen Stempel aufzudrücken. Allein vergebens. Steté was man gewungen, an einen schon vorhandenen Styl anzuschließen, der dann für unsere Cultur etwas modificirt wurde. Der Ruf nach einem neuen Styl wurde immer schärfer und dringender. Und trotzdem ist er noch in weite Ferne gerückt zu sein. Da steht er nun plötzlich vor uns und versucht, in Wien einzubringen. Denn noch ist er ante portas.

Daß die ersten Anzeichen des neuen Styls in Oesterreich just bei einer Veranstaltung auftreten, die zu Ehren unseres Monarchen stattfindet, dünkt mir ein gutes Omen. Daß doch der Architektur noch am meisten unter allen Künsten guten Grund, ihrem kaiserlichen Protector dankbar zu sein. Was hat sie ihm nicht Alles zu verdanken! Sie würde man mit den reichen Mitteln umgegangen sein, wenn nicht der Kaiser selbst eingegriffen hätte, zum Wohle der Kunst und zum Mißvergnügen derjenigen Herren, die durch das langjährige Sitzen im Hochbau-Departement zu den Monumental-Arbeiten besonders prädestinirt erschienen. Man denke nur an die sensationelle Berufung Semper's, eine kaiserliche That, die mir auch immer nicht genugsam gewürdigt erscheint. Und nun kommen Wiener Architekten und entbieten ihren Schirmherren zu seinem Jubiläum ein wertvolles Geschenk: den neuen Baustyl, als Ergebniß ihrer Bemühungen innerhalb seiner Regierungszeit.

Der neue Styl ist da. Doch wird er nicht überall freudig begrüßt werden. Viele haben vielleicht gar nicht das Verlangen nach ihm empfunden. Und Viele haben sich ihn anders gedacht. Man kann aber das Zeugniß nicht versagen, daß er bescheiden auftritt. Anläßlich einer Ausstellung ist gekommen, bleibt draußen im Parke und verspricht gleich im vorhinein, sich nach sechs Monaten wieder zu empfehlen. Erst auf eine neuerliche Einladung würde er in Wien dauernd Fuß fassen. Unterdessen will er nicht weiter sein als Ausstellungsstyl. Als solcher aber hat er keine Concurrenz. Die Ausrede, daß es keinen eigenen Ausstellungsstyl gibt, gilt nicht mehr. Da die früheren Culturepochen keine charakterisieren, die Architekten aber ohne directe Vorbilder nichts anzufangen wußten, so mußte man sich mit Surrogaten begnügen. Bald war ein griechischer Tempel, bald ein mittelalterisches Haus, bald persisch in Brettern und Stuck imitirt worden. Den griechischen Tempel wurde der Gotthelf geopfert? Feelgeschossen, Maschinen wurden darin aufgestellt. Und in dem mittelalterlichen Hause wurde mal gar gesoltert? Schon gar nicht, die modernen Bildungsmittel kamen darin zur Ausstellung. Solche Ausstellungsbauten waren im besten Falle gute Bitze, die man sich während der kurzen Zeit wol gefallen ließ.

Aber der beste Witz verliert an Kraft, wenn er zu oft wiederholt wird. Es gibt Leute, die ihn noch nicht oft gehört haben und bei ihnen wieder zu ihren wünschen. Die werden vor der Rotunde auch auf ihre Rechnung kommen. Die richtigen Ausstellungsbummler aber, die keine Ausstellung versäumen, die es nun in Chicago oder Nischnei-Nowgorod stattfindet, denen werden, daß (Man mache die obligate Handbewegung.) Neues mußte daher um jeden Preis gebracht werden. Man wor gezwungen, den Ausstellungsbauten von ihrer ernsten Seite anzupacken. Man versuchte es nicht mehr, das Publicum zu amüsiren, sondern man bemühte sich, dem Zweck, dem diese Gebäude dienen, architektonisch zum Ausdrucke zu bringen.

Das war ganz nicht leicht. Zwei Bedingungen zu erfüllen. So sollte jedes Gebäude zeigen, daß es nicht für einige Zeiten, sondern nur auf die Dauer der Ausstellung errichtet sei und sollte sein Material künstlerisch beherrschen und nicht ein wertvolleres imitiren, es sollte die Aufmerksamkeit der Menge auf sich ziehen und, last, but not in any rate least, durch seine Form auf die darin ausgestellten Gegenstände schließen lassen. Vier Bedingungen, von denen jede einzelne vollständig neu ist, von denen jede einzelne große Kraft eines ganzen Künstlers erfordert. Man wird einwenden, daß die Ausstellungsbauten von der Verpflichtung frei sein, schön zu sein. Gewiß. Wenn sie nämlich diese Bedingungen erfüllen, sind sie es auch. Es ist selbstverständlich, daß diese nur bei den wenigsten Bauten zutrifft. Manche erfüllen drei, andere zwei und bloß eine dieser Bedingungen. Die meisten aber gar keine. Das ist recht. Denn dadurch können wir ihre Auswahl treffen. Anfangs werden wol die Gebäude, die in der alten Bauweise entstanden sind, den meisten Beifall finden. Da man die Neue muß sich eben erst gewöhnen. Von dem gesunden Urtheile der Wiener Bevölkerung aber kann man erwarten, daß im Laufe des Sommers eine Umwerthung der Geschmäcke stattfinden wird, so daß den Männern, welche die bornenvolle Bahn der künstlerischen Pfadfinder betreten haben, die allgemeine Anerkennung nicht versagt bleibt. Wo immer auch bisher Ausstellungen in den letzten Jahren stattfanden, in Rußland, Belgien, Deutschland, Italien, überall fragte bisher der Muth aus Künstler. Es mußte die Ausnahme jener künstlerischen Kräfte getreten werden, welche die künstlerische in Verein durch einen vornehmen Rahmen zum Siege führen sollen. Und da ist es nun unsere vornehmsten Leute zu finden wissen. Aber eine Bitte: Man spare bis daß eigentliche Urtheil zum Schlusse der Ausstellung auf. Denn etwas bange könnte Einem auch noch werden. Für Vornehmheit und die Gegentheil hat man nämlich nicht überall ein sicheres Unterscheidungsvermögen.

passiren, daß man alle Vitrinen bis auf einige Ausnahmen mit einer Oelfarbe gestrichen hat, die den Zweck hat, Mahagoni zu imitiren. Es ist doch keine Schande, für Geld für Mahagoni-Vitrinen zu haben. Aber den Leuten mit einem minderwerthigen Material die Augen auszuwischen zu wollen, zeigt von recht fragwürdiger Eleganz. Die Styl aber auch eine angestrengte Vitrine steht vornehm präsentiren kann, zeigt der eine (Gerold-Martin) gestrichene Schrank besten von Maison Spitzer, nebenbei die vornehmste und daher mustergiltige hölzerne Vitrine in der Rotunde (Architekt Decsei).

Bei der Anlage der Ausstellung hatte Chef-Architekt Bressler einen schweren Stand. Die Mittel waren gering, der Platz beschränkt, die diebigen Anlagen mußten thunlichst geschont werden. Leute, welche die Ausstellungen des Auslandes in den letzten Jahren gesehen haben, werden die Verwerthung des Wassers, seit Chicago der Hauptreflex einer jeden Exhibition, sehr vermissen. Auf einen großen Mittelpunkt, auf einen großen Zug in der Anlage mußte Bressler verzichten. Gedrängt stehen die Pavillons in zwei parallelen Avenuen nebeneinander, die durch je zwei lichtspendende Glasoberlichten unterbrochen sind. Dem modernen Schlachtruf "Mitte frei!" auf den Städtebau zuerst von Camillo Sitte angewendet, möchte man auch gegen den schweren Musikpavillon ausstoßen, der den freien Platz, welcher als Erweiterung zu den vielen Ruineen dient, vollständig zerreißt. Er wäre ein leichter lustiger Bau in einem Sommer, wenn schon die Mitte betont werden soll. Aber der Pavillon ist Ausstellungsobject. Mögen die Maison an dem aufdringlichen Patron recht viel auszustellen haben. Vielleicht geschieht es dann in Zukunft anders. Eine Neuerung ist auch die Erhöhung des Fußbodens in der Rotunde. Gewiß keine Verbesserung. Aber sie wird wenigstens jene Stimmen zum Schweigen bringen, die sich Wunder was von dieser Maßregel versprochen haben. Auf alle Fälle ist eine dankenswerthe Experiment. Die Rotunde selbst hat ihre alte gemeinth, wenn schon die Mitte betont werden soll.

Der Rundgang durch die Ausstellung, der Reihenfolge, wie er für den kaiserlichen Jubilar festgestellt wurde, lehrt uns auch, daß die Rotunde nicht radial, sondern nur durch zwei Axen getheilt ist, welche die vier Hauptportale miteinander verbinden. Den Eingang in die Rotunde von Südportal aus bildet das Kaiserzi vom Chef-Architekten Bressler, während gegenüber im Nordportal die Heeres-ausstellungs-Gegenstände (Maler Koller und Architekt Fischl), im Westportal der Silberhof und im Ostportal der Seidenhof untergebracht sind. In der Arbeit der Herren Koller und Fischl macht sich das Betreben bemerkbar, die dekorative Wirkung nur mit den Ausstellungsgegenständen zu bestreiten, während Architekt Decsei, der Erbauer des Seidenhofes, die Architektur in seinen Dienst stellt. Auf Originalität macht der Seidenhof keinen Anspruch. Aber vornehm ist er und birgt in seiner Mitte ein Juwel, ein wie wenig Kunstausstellungen "nur" als decorative Mittel zur Verfügung stellen. Die zwei Kaiserstatue von der Straßer. Die zwei Nebenfiguren sind in der vollständigen Neuerungen der Wiener Plastik. Für ein solches Können hat die deutsche Sprache nur ein Wort, für diese Kunst gerecht strengend. Im Silberhof feiert auch ein großer Künstler einen Triumph. Otto Wagner hat für den Gold- und Silberschmied Klinkosch eine Vitrine entworfen, die — mit den sachsten Mitteln, aber durch echtes Material — Silber — einer großen Wirkung sicher sein kann. Wie gerüstet macht die hohle Aufgeblasenheit eines Nachbars, eines Rococo-Pavillons!

Ein Schüler Otto Wagner's, Architekt Pletschmil, hat den vornehmen Rahmen geschaffen, der der Interieurs unserer Wohnungs-Industrialen einschließt. Zwei Säulen, die vom Bildhauer Schimkowitz (auch mit Pletschmil die Concurrenz des Gutenberg-Denkmals gewann) mit Glühlichter tragenden Genien versehen wurden, führen von Silberhof in diese Abtheilung. Wieder einer, der nicht mit den landläufigen architektonischen Gemeinplätzen arbeitet, sondern mit Hilfe der Materialien neue, ungeahnte Effecte hervorzubringen sucht und — hervorbringt.

Vor dem Nordportale, unter einer Rotunde und Lagerhaus, hat der landwirtschaftliche Abtheilung ihren Platz gefunden. Der große freie Platz wird von Gebäuden umsäumt, die Einem weder kalt noch warm machen. Von hier aus führt die Avenue der Ernährung ihren Anfang. Im Volksmund hat das schon einen Spitznamen. Die Nähe des landwirtschaftlichen Ausstellung hat es wol bewirkt, daß hier so, sagen wir — landwirtschaftlich klingt. Nachdem aber wohlgezogene Menschen nicht essen, so dünkt mir der Ausdruck "Eß-Avenue" richtiger.

Wirklich erfreulich ist die architektonische Ausgestaltung der Wiener Volksküche in der architektonischen Ausgestaltung dieser Avenue ausgefallen. Links macht der Pavillon Törley den Anfang. Ich glaube mich verhört zu haben, als ich den Namen des Malers vernahm, der diesen Pavillon "geschmückt" hat. Ich habe nicht den Muth, ihn der Oeffentlichkeit preiszugeben. Unter der Fülle voller Uneinheitlichkeit macht sich der anspruchsvoll Pavillon des Rothweinhändlers Stummer angenehm bemerkbar. Eine Rococo-Capelle, in der man Wein trinkt. Also noch ein Wiß, aber diesmal der gute. Architekt: Freiherr v. Krefel. Architekt Dusensehne verfügt sich auch in Güsse zu recht oder in rückständigen Namensbrüder wenig Glück — sie sind sämmtlich Defür steht aber eine der besten Bauten auf dieser Avenue, die mit allen vier Bedingungen, in der das Brauerei-Restaurant vom Chef-Architekten Bressler, den vom Bildhauer Hejda und den Malern Bild und Weigand in ausgeführt wurde. Das Hauptrestaurant vom Architekten Tropsch,

gegenüber das Hauptcafé vom Architekten Berchtevi schließen den Platz, der als Mittelpunkt der Ausstellung gedacht ist, wirkungsvoll ab. Die Maler Kurzweil und Lixt haben das Hauptrestaurant ausgeschmückt.

Die Hauptavenue wird eröffnet durch den Pavillon der Urania (Architekt Baumann). Maler Engelhardt lieferte den Bildschmuck. Reizend ist das Weinhaus der Frau Bertha Lurg (Architekten Knoll und Hadrid) und vorzüglich in der Farbe die American-Bar, die merkwürdigerweise den Architekten Oberländer zum Verfasser hat. Gegenüber befindet sich der Zacherl-Pavillon den Architekten v. Krauß und Tolk, während das schmiedeeiserne Wetterhäuschen den Architekten Dresler entstammet. Man sieht, ich nenne nur die besten Sachen. Aber hier wäre es wol am Platze, gegen eine Verunstaltung in der Fisch- und Krebsenrestaurant hervorbringt, energisch zu sprechen. Die Zacherl-Ausstellung von Fellner & Helmer hält sich in der wohlthuenden Wirkung, die sie bereits "Alt-Wien" verspricht hat. Restaurant Sacher von Baumeister Glaser ist trotz der amerikanisirenden Formen in Heldentracht. Dazu Rococo-Details — nein, es gibt wirklich nicht. Architekt Urban hat die beiden bosnischen Pavillons gezeichnet, Architekt Marmorek den Pavillon Scheffel. Von rechts grüßt der Pavillon der Gruppe "Bildung" herüber. Architekt Baumann und die Maler Hohenberger und Leny haben ein sehr wirkungsvolles Bauwerk geschaffen. Architekt v. Krauß hat die größten Interessen verfolgt, den größten und das besten Pavillon in der Ausstellung. Gemalt sind die figurenreichen Hohlkehlen von Maler Graf. Das Naturdetail ist wol etwas zu brutal, welchen Vorwurf man auch nicht dem gegenüberstehenden Pavillon der Stadt Wien von dem Architekten Dresler ersparen kann. Beide Pavillons haben überdies auch den Fehler, daß sie gerade so gut aus Ziegeln erbaut sein könnten. Das ist aber den Pavillon den Städtebureau ungeschlossen, so haben aber der beste ist, den kein Ausstellung aufzuweisen hat. Entworfen vom Architekten Stiaßni im Atelier und unter der Leitung des Hofraths v. Förster stehenden Hochbau-Departements im Ministerium des Innern, wurde dieser wol Pavillon unter der Mitwirkung des Architekten Bauer ausgeführt. Die Bildhauer-Arbeit ist von Hejda, der sich damit als decorative Genie ersten Ranges erwiesen hat.

Auf alle diese Bauten, auf die Fülle decorativer und kunstgewerblicher Arbeiten werde ich demnächst eingehend zu sprechen kommen. Zur heute sei nur constatirt, daß diese Generalprobe zur Pariser Weltausstellung uns mit den frohen Gewißheit erfüllen kann, daß wir auch im Wettstreite mit fremden Nationen einen ehrenvollen Platz einnehmen werden. Mögen aber auch auf diesem Platz zu erkämpfen berufen sind, die richtigen Lehren aus der Generalprobe gezogen werden. **Adolph Loos.**

Die Urania.

Der Wanderer durch das lauschige Thal mit seinem sprudelnden Bache, zwischen den überhangenden Felsen wirft gern einen Blick in das Getriebe des zufällig am Wege befindlichen Hochofens, dessen unheimliche Gluth mit ihren wogenden Flammen ihm einen anziehenden Gegensatz zu der erhabenen Stille der Natur bietet, in der er sich bis jetzt bewegte. Er hat damit von der Technik der Eisengewinnung ebensowenig einen Begriff gewonnen, wie Jemand ein Entomologe genannt zu werden verdient, weil er einmal zufah, wie ein Falter die Blumen umgaukelte. Wie viele Menschen gibt es, die nicht einmal einen Effect bewundern und die überhaupt nicht einmal fragen Hochofen gesehen haben?

Nicht nur solchen, sondern auch für diejenigen, deren metallurgische Kenntniße sich auf die gelegentlichen Vorlesungen an einem solchen Etablissement beschränken, hat wissenschaftliche Theater, wie die "Urania" unserer Jubiläums-Ausstellung verheißt, ein wichtiger Bildungsfactor. Niemand wird zweifeln, daß sich die Vorführung aller einschlägigen Proceduren vor seinen Augen, auf der Bühne, lebendiger dem Geiste einprägt, als die besten Schilderungen oder die vorzüglichsten Abbildungen. Man hat hier den Stücke ein Drama der guten Darstellung beschließen die Wege darum. So steht es die Erze und lernt ihre Förderung aus dem Schachte kennen, beigleichen die Unterscheidung zwischen gehaltvollem und taubem Gestein. Mit Spannung verfolgt er das Schicksal des gepochten Rohmaterials und die Ableitung des sich entwickelnden Kohlen-Dioxydes, wenn man auf Spatzeisenstein, wie gleich in Steiermark, handelt. Vor seinen Blicken fließt die unreine Eisenform aus dem Osen, um nun, geschämmt oder gefrischt, im Puddling- oder Bessemer-Proceß umzuwandeln zu werden.

Für diese Erscheinung wird weniger angeregt sein, als für Jubilarum einen belegenden Effekt, wie der "Reise durch Oesterreich-Ungarn", die das Urania-Theater ebenso wie "Das Eisen" in nächster Zeit inceniren wird.

Nansen's Buch: "Jn Nacht und Eis" macht trotz seiner Lebendigkeit einen tiefen Eindruck und dramatisirte "Kampf um den Nordpol", dessen Wirkung in sechs Jahre und bei den zweihunderten Aufführung in Berlin beobachten können und dessen Drucksache vom Wiener Institute übernommen wurde. Es wird hier nicht angestrebt, in kundig empfindsamen Gemüth Schaudern zu machen, wie sich zeigt in der tiefe Welt des Eises bereitgiebig wird; das Publikum soll dadurch befähigt werden, die dasselbst waltenden Naturgewalten zu verstehen. Nur der Nordpolfahrer selbst kann derlei lebendige Gestaltungen der Phänomene in den arktischen Regionen vorführen. Für ihn finden diese Productionen ebensowenig statt wie für den Technologen der des Eisens, und den Geograph der der dargestellten Reise durch Oesterreich-Ungarn entrathen kann.

The point is, rather, that in these articles Loos makes very little reference to *disornamentation*, or, to put it more clearly, says next to nothing about ornament in that *modern* sense which consists in first criminalizing it and then summarily condemning it to disappear—a sense he seems to have imposed. On the contrary, the way Loos writes in these articles about ornament, or art, or craft, or utility... is perfectly recognizable: it belongs, first and foremost, to a tradition that not only he but many other German or Austrian architects of his time embraced as their own: that of Semperian 'materialism'.

'Materialist'—thus, in quotes, as a form of ironically stubborn affirmation in the face of his critics—is the word with which Loos qualifies Semper right at the start of his career as a writer, in the second of the articles published in his lifetime, in *Die Zeit*; curiously, this is a defence of Olbrich and Hoffmann, whom he considers 'disciples of Semper' who put into practice 'the master's phrase: every material has its own formal language'.[3] In this article Loos is already criticising, as he will go on to do on so many occasions, those who 'paint wooden walls as if they were plastered and treat pieces of plaster like wood', but his criticism is based not on the supposedly criminal or degenerate nature of ornament, but on the necessity expressed in 'the master's phrase': in other words, it rests on the 'materialism' on which a whole architectural tradition is instituted; on that tradition, then, constructed or invented as all traditions are, that Loos at other moments calls classical: that of the Greeks and the Romans, or that of Schinkel and Semper. In another article published just a few months later, written not for the general public but for the specialist readers of an architecture magazine, *Der Architekt*, Loos defines the issue very precisely. First of all he makes it clear that 'architectural art' is, by virtue of its permanence in time, 'the most conservative'.[4] Obviously, however this claim was interpreted by the magazine's readership of *modern* architects, who would have seen that condition as a burden and a constraint, Loos has to be taken here in positive terms. This is, in effect, the *state* of architecture: that of being necessarily, fatally, more resistent than any other art to novelty or fashion. Loos often expressed pride in the fact that his 'Café Nihilismus' had impassively withstood the giddy pace of profligate novelty: 'The Café Museum,' [fig. 2] he wrote, for example, in 1910, 'still exists today, while all the modern woodwork of the thousands of others has been thrown into the lumber room.'[5] That conservativism, that necessary adherence of architecture to a time that is both its own and collective, without temporality, is what allowed Loos to draw a line that, although marked by ups and downs, according to him, begins with the 'recognition of spiritual superiority of classical antiquity' and concludes, provisionally, in Schinkel [fig. 3] and Semper.

fig. 1

13

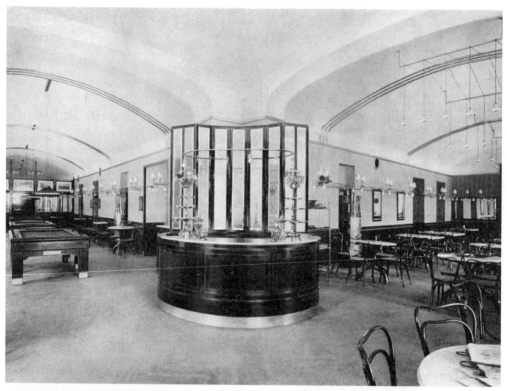

fig. 2

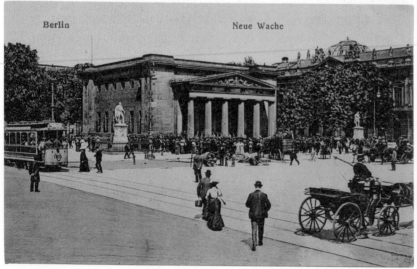

Berlin Neue Wache

fig. 3

Of the latter in particular Loos says that he dominated his time because he succeeded in making 'the fewest possible concessions' to it and—just to confuse things—because he defended 'unceremoniously the classical point of view'. In the first of these assertions we can all recognize, without a doubt, the day-to-day endeavours of Loos; the second, however, has largely been redacted from the vision we have been offered of the history of modern architecture. However, it is the one that most literally links him to the tradition in which his 'materialism' asks and needs to be recognized. Not for nothing, a few lines further on in the same article Loos forthrightly declares that 'the great architect of the future will be a classicist'.

And who will that architect of the future be? 'Signs of this are already apparent in the new ornamentation of the Wagner school.' Loos prudently speaks only of 'signs', but what evidence might there be in support of this prediction? Some years later, in 1911, in an article specifically devoted to Wagner,[6] Loos returned to the same question and, in principle, it would seem, in identical terms: after proclaiming himself a 'defender of tradition'—that is, one who makes no concessions to his time—he goes on to say that 'Wagner is denying [tradition]': Wagner does make concessions to his time. The conclusion, however, a few lines below, casts off prudence to close the circle that had been left open by those 'signs' glimpsed some twelve years before. Loos now notes 'with pride that the greatest architect of the day is Austrian and lives in Vienna' and discloses to his readers what everyone else apparently already knew, namely that 'the cornerstones of architectural development in the nineteenth century are Schinkel, Semper, Wagner'. In 1911 Loos affirms this *in spite of everything* (*trotzdem*) and *in spite of everything* he feels he belongs to that *classical* tradition.

But it is not with the crucial issue of the relationship between Loos and Wagner that I intend to deal here. Let's go back to 1898, to the article in *Der Architekt* and to exactly what Loos says about the Wagner school: that the 'signs of the future' are apparent in its 'new ornamentation'. I want to emphasize these words: Loos is not demanding for the 'architect of the future' the elimination of ornament, nor condemning him to that for his criminal and degenerate character, but invoking a nascent 'new ornamentation': the 'new ornamentation' corresponding to his time. Certainly, Loos devotes part of his article to championing manual labour, tools, techniques and materials, but another and no less important part is devoted to the 'formal language': in other words, style and ornamentation. The 'architect of the future', he tells us, will have at his disposal a 'much richer formal language' than that available to the architects of the past, thanks to his greater knowledge of historical styles and thanks to the 'findings of the new archeology'. Certainly any 'formal language',

any 'new ornamentation' that may arise there will liberate the 'architectural art from foreign elements' and return it to 'the pure classical way of building': that is the mission of the 'higher spirit' that Loos called the 'superarchitect'. But neither am I interested here in these flirtations with Nietzsche. What I want to insist on is how directly Loos's text reflects the essentials of the theory of style—of ornament—of Semper.

Allow me this simplification: first, starting from the fabric—the garland, the knot [fig. 4-11]—which constitutes for him the prime example of manual labour, Semper claims that ornamental forms come from the precise alignment between need, material and technique; secondly, the identification of ornament as the clothing or cladding (*Bekleidung*) of the building—which derives from that initial concentration on fabric—allows him to interpret it as something intimately linked to construction—which is where the technique resides—in being its outcome and expression, but also as something superposed on it, as its covering, more or less eloquent in the same sense that a person's dress may be.[7] The ambiguity here—an ambiguity which Semper maintained unresolved through the whole course of his theoretical work— became for the turn-of-the-century Viennese architects a need to choose, especially for those with whom Loos had the most intense love-hate relationship, Wagner and Hoffmann, who clearly and radically—especially the former—chose the option of the cladding, or literally, to use a word that encompasses all of the various meanings, the curtain — but an ornate curtain. In what sense might this mean, for Loos, making concessions or not to his time? He explains this very clearly in an article devoted precisely to the 'principle of covering',[8] written for the general readership of the *Neue Freie Presse* and largely an undisguised gloss of the theories of Semper I have just outlined—'the principle of cladding, which was first articulated by Semper...'. The first thing that humanity discovered, Loos says, was cladding—'the covering is the oldest architectural detail'—and only later came the walls that formed the spaces. Modern architects, however, proceed differently, in just the opposite way: first they imagine spaces, then they enclose these with walls and finally choose the claddings. All of this led Loos to expound his 'law of cladding', which states that we should never confuse the cladding and that which is clad. Loos therefore stood firm—let's use this paradox—on the marrow of that founding Semperian ambiguity, and we need only return to the discourse at once simple and double of the article in *Der Architekt* to see this: first, the praise of manual labour —of the quarryman, the mason, the carpenter—which has no need of the architect's intervention precisely because it necessarily unites material, technique and form, and, secondly, the appeal to the 'superior spirit', to the 'superarchitect', with all that this implies, as we have seen: the purification of the 'formal language' and the return to the 'classical way of building'.

herbeigeführt, die den ästhetisch-ornamentalen Charakter des Gewirks zum Theil vernichteten oder doch zu bedeutungsloser Monotonie herabsetzten.

§. 54.

Das Geflecht (Zopf, Tresse, Naht, Bohrgeflecht, Ratté).

Das Geflecht hätte vielleicht vor dem Strickwerk unter den Producten der textilen Künste genannt werden müssen. Es ist nächst dem Gewirn dasjenige, welches bei der Bereitung der Gebinde benützt wird; doch dient es auch zur Bereitung von Bedeckungen. Das Geflecht gilt ein solideres Strangwerk als das Gewirn, indem die einzelnen Stränge,

woraus es besteht, mehr nach ihrer natürlichen Richtung, d. h. im Sinne der absoluten Festigkeit fungiren, wenn dasselbe gespannt wird. Zugleich hat es den Vorzug, sich nicht so leicht „abwölben", d. h. in seine elementaren Fäden auflösen zu lassen. Zum Geflecht gehören wenigstens drei Stränge, die abwechselnd übereinander greifen. (Vide Figur.) Doch lässt sich die Zahl der Stränge beliebig vermehren, wobei

erforderlich, wo man decken, schützen und abschliessen will, und sind zugleich die sich selbst erklärenden Symbole der Begriffe des Schutzes, der Deckung, des Abschlusses in der Kunst geworden. Sogar die Sprache hat in der Bezeichnung dieser Begriffe ihre Ausdrücke von den textilen Künsten entlehnt, die somit, wie es den Anschein hat, älter sind als die Entstehung unserer jetzigen sprachlichen Formen. Dasselbe gilt von den ältesten religiösen Symbolen.

§. 6.

Die Reihung.

Die Reihung ist ein Gliedern der einfachen und deshalb noch ästhetisch indifferenten Bandform und wohl das ursprünglichste Kunstprodukt, die erste thatsächliche Kundgebung des Schönheitssinnes, der bestrebt ist, den Ausdruck der Einheit durch Vielheit zu bewerkstelligen, die sich in einer eurhythmischen Form verbinden und zugleich als Mehr-

heit der Einheit, auf welche sich die Reihung bezieht, gegenübertreten, wodurch die Autorität und Einheitlichkeit des Subjektes mehr betont und gehoben wird.

Der Blätterkranz ist vielleicht die früheste Reihung; er behielt als Corona in den Künsten aller Zeiten sein altes Vorrecht als Symbol der Bekrönung, der Begrenzung nach Oben, und, im gegensätzlichen Sinne, zugleich als Symbol der Begrenzung nach Unten,

die Zerstörung einer Masche das ganze System nicht afficirt, und leicht auszubessern ist. Hierin liegt zugleich das Kriterium des Netzgeflechts, das in anderer Hinsicht die mannichfachsten Variationen gestattet, in diesem einen Punkte aber sich unter allen Umständen gleich bleibt. Bei dem Altou war der spanische Hanf zu Netzen der beste. Auch der kunstreichste hatte in dieser Beziehung Berühmtheit. Man machte Netze, worin Eber gefangen wurden, von so grosser Feinheit, dass ein einziger Mann so viel davon auf seinem Rücken tragen konnte, als hinreichte, um einen ganzen Wald damit zu umstellen. Doch diente dasselbe Geflecht in dichteren Maschen auch als Brustharnisch, wenn die Fäden, obschon an sich fein, dennoch aus drei- bis vierhundert Einzelnfäden zusammengewirkt waren.

Diese Industrie scheint bei den Aegyptern besonders geblüht zu haben.[1] Dieselben Aegypter machten auch Ziernetze aus Glasperlenschnüren, wovon sich mehrere sehr hübsche Exemplare erhielten. Dieser Schmuck war auch bei den Griechinnen, so wie bei den hetruskischen und römischen Damen gewöhnlich. In Indien dient das Netz als reiches Motiv für Kopfbedeckungen und Halsbänder, wobei der Geschmack in der Alternanz der Maschen und der Distribution der Zierrathen und Berloks bewunderungswürdig ist. Das Mittelalter[2] liebte und Spanien erhielt in seinen Werke das zierliche Netzwerk als Schmuck des Haupthaars und leichten Körperhülle.

In der Baukunst, in der Keramik, überhaupt in allen Künsten wird das Netz zur Flächenverzierung und erhält öfters strukturensymbolische Anwendung als Schmuck der Wölbte und baulichen Theile, z. B. der Panzen der Vasen.

[1] Cfr. Plinius XIX. I. und Herodot.
[2] In Ebners's Trachten und in dem Werke Moyen-age et renaissance, Artikel Costumes, sind hübsche mittelalterliche Netze gegeben. Das Museum für practical art und sciences in Kensington enthält indische Netze und Schmuck in Menfaen.

tung hatte, darüber geben uns die assyrischen Basreliefs, die Malereien der ägyptischen Monumente, und vor allen die hellenischen und etruskisch-italischen Vasenbilder, zunächst in Beziehung auf Bekleidung im engeren Sinne des Wortes, d. h. auf Kostüm, Kleidertracht und Draperie, un-

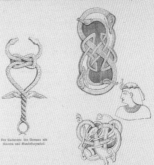

Der Gürtenotz des Hermes mit Raren und Handelbogenstab.

Hätsche und Geschmücktürkische Schlangengewände, die Aegis der Aegypter.

züglige und höchst interessante Nachweise. — Dass dasselbe wiederum keine Anwendung fand und absichtlich verlangt wurde, sobald die Unzulänglichkeit des Materiales oder der Mittel es nöthig machte, etwas aus Stücken zusammenzusetzen, was durch eine gemeinsame Bekleidung for-

fig. 4, 5, 6, 7 following pages fig. 8 to 11

Aus der Naht ging das splendide und luxuriöse Spitzenwerk hervor, jene durchbrochene Arbeit in Zwirn oder Seide, welche das Alterthum gar nicht oder höchstens in ihren Rudimenten kannte und benützte, die Glorie der modernen Toilette. Das Spitzenwerk[1] (lace, point, dentelle, pizzi, merletti) lässt sich in zwei distinkte Klassen theilen: Nadelspitzen (guipure) und Klöppelspitzen. Erstere werden aus freier Hand mit der Nadel gemacht, letztere auf dem Kissen mit Hülfe der Klöppel.

1) Guipure ist das älteste Spitzenwerk. Man unterscheidet viele Varietäten: Rosen-Points, portugiesische Points, maltesische Points, Points von Alençon und brüsseler Points. Der Grund dieser letzteren ist auf dem Kissen vorbereitet, die Nadel aus freier Hand führt das Motiv aus. Alle andern genannten Spitzen sind durchweg freie Handarbeit.

Alle diese Sorten sind unter sich charakteristisch verschieden, aber gemeinsam leicht von Klöppelwerk dadurch zu unterscheiden, dass sie alle aus Variationen der beiden Stiche bestehen, die auf den unterstehenden Figuren 1 und 2 dargestellt sind.

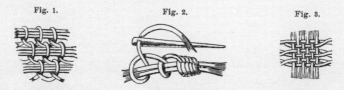

Fig. 1. Fig. 2. Fig. 3.

2) Bobinet, Kissen- oder Klöppelarbeit ist eine Erfindung der neuern Zeit. Man nennt Barbara Uttmann aus Sachsen als die Erfinderin und gibt das Jahr 1560 als das Jahr der Erfindung an.

Man unterscheidet spanische, gegründete spanische, sächsisch-brüsseler, flämisch-brüsseler, mecheler, valencienner, holländische, Lille-Spitzen. Dann noch Chantilly-, Honiton- und Buckinghamshire-Spitzen, zuletzt Blonden.

Der Process des Spitzenklöppelns besteht aus einer Art von

[1] Siehe die Notiz des Herrn Octavius Hudson, Professors der Abtheilung: wowen fabrics in dem Department of Science and Art zu London, in dem „first Report of the Dep. of Science and Art" vom Jahre 1854. Hierbei versäume ich nicht, auf die schöne textile Sammlung des genannten Departements zu Kensington bei London wiederholt aufmerksam zu machen, die auch eine Reihe von Spitzenproben in systematischer Ordnung enthält.

gemischter Weberei, Zwirnerei und Flechtung. Das Dessin der meisten
Sorten wird durch ein Zusammengreifen der Fäden hervorgebracht, wie
es beim Weben der Leinwand in Anwendung kommt (Fig. 3); — der
Grund dagegen wird durch Flechtung der Fäden erzeugt, oder bei an-
deren Sorten durch einfaches Zwirnen. (Siehe Figuren 4 und 5.)

Fig. 4. Fig. 5. Fig. 6.

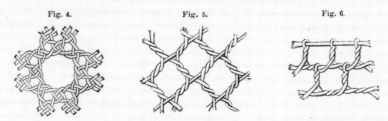

Ausserdem kommen noch Variationen zwischen diesen Proceduren
vor, die aber im Wesentlichen das Charakteristische der geklöppelten
Spitzen bilden.

Die älteste bekannte Sorte von Spitzen ist auf grober Leinwand
ausgearbeitet. Man zog Fäden aus und füllte die Lücken mit Stichen
gleich Fig. 1. Die Leinenfäden sind dabei mit dem Stiche Fig. 2 über-
sponnen. Diese Methode bringt stets geometrische Muster hervor. Man
findet sie angewandt zu Nähten und Bordüren an den ältesten Altardecken
und anderen kirchlichen Paramenten.

Man führte die ältesten Points auf einem Pergamentblatte aus,
worauf die Muster gezeichnet und die leitenden Fäden aufgenäht waren;
wenn die Arbeit fertig war, wurde das Pergamentblatt abgetrennt.

Diese ältesten Points sind meistens italienische und portugiesische
Arbeit. Venedig war der berühmteste Fabrikort. Erst unter Colbert
(um 1660) wurde die Spitzenfabrikation in Frankreich eingeführt.

Die französischen Points (points d'Alençon) sind mit den alt-portu-
giesischen und den modernen Brüsseler Spitzen dem Prinzipe nach
identisch. Fig. 6 zeigt den Stich für den Grund, Fig. 7 den für das
Muster oder die Füllung.

Die brüsseler Points (points à l'aiguille) zeigen beistehende Varietät
des Grundstichs (Fig. 8). Später wurde der Grund oder das Netz
geklöppelt und noch später mit Maschinen gemacht.

Die Flechtspitzen (plated lace) sind von den auf Leinengrund aus-
geführten Spitzen oft schwer zu unterscheiden. Die ältesten geklöppelten
Spitzen sind dieser Art.

sollen. Ihr Stil richtet sich daher zunächst nach den Stoffen, die sie
umsäumen oder garniren sollen. Sodann nach der Person, die sie trägt,
der Veranlassung, wobei sie zum Putze gewählt werden etc. etc. Desto
schwieriger und verwickelter ist für sie jede Stiltheorie, so weit diese die
Prozesse berücksichtigen will, die alle zu ihrer Verfertigung bereits
erfunden sind und noch erfunden werden könnten.

Das Geflecht trat schon in den zuletzt genannten Produkten als
flächenbereitend auf; diesen Zweck erfüllt es noch entschiedener in
der eigentlichen Matte (der geflochtenen Decke).

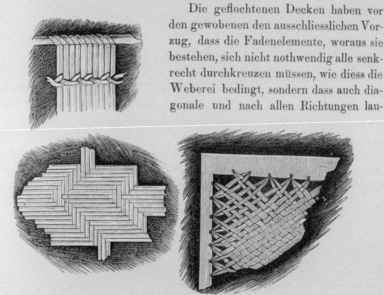

Die geflochtenen Decken haben vor
den gewobenen den ausschliesslichen Vor-
zug, dass die Fadenelemente, woraus sie
bestehen, sich nicht nothwendig alle senk-
recht durchkreuzen müssen, wie diess die
Weberei bedingt, sondern dass auch dia-
gonale und nach allen Richtungen lau-

Aegyptisches Geflecht.

fende Fäden in die Textur eingeflochten werden können. Dieser Vor-
zug soll in dem Geflechte auf alle Weise behauptet, sichtbar
gemacht, zum Characteristicum erhoben werden.

Die Kunst des Bereitens der Decken aus Rohrgeflechten ist uralt
und hat seit den Zeiten des alten Reiches der Pharaonen keine wesent-
lichen technischen Fortschritte gemacht; in der ästhetischen Auffassung
des Motives waren dagegen die damaligen Aegypter, sind noch jetzt die
Irokesen Nordamerikas und manche andere Wilde und Halbwilde unbe-
fangener, glücklicher und sinnreicher als wir heutigen Europäer mit
unserer bewunderten mechanischen Allmacht.

zu werden, wenn er kein Phantasiebild,
sondern ein höchst realistisches Exemplar
einer Holzkonstruktion aus der Ethnologie
entlehnt und hier dem Leser als der vitru-
vianischen Urhütte in allen ihren Elementen
entsprechend vor Augen stellt.

Nämlich die Abbildung des Modells einer
karaibischen Bambushütte, welches zu Lon-
don auf der grossen Ausstellung von 1851
zu sehen war. An ihr treten alle Elemente
der antiken Baukunst in höchst ursprüng-
licher Weise und unvermischt hervor: der
Heerd als Mittelpunkt, die durch Pfahl-
werk umschränkte Erderhöhung als Ter-
rasse, das säulengetragene Dach und die
Mattenumhegung als Raumabschluss oder
Wand.

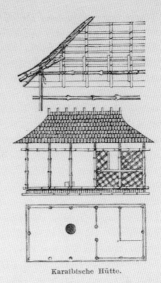

Karaibische Hütte.

§. 146.

Toskanisch-römische Holzarchitektur.

Wir wollen nicht wieder auf die archaischen Holztempel Griechen-
lands zurückkommen, deren letzte Ueberreste noch gegen Ende des
II. Jahrhunderts nach Christo Pausanias sah, sondern nur einen Augen-
blick bei jenem toskanischen Tempelbau verweilen, den wir aus Vitruv's
Beschreibung etwas genauer kennen. Er bestand aus einer Mischkon-
struktion aus Holz und Stein und auch an ihm hatte der erstgenannte
Stoff nur einen mittelbaren Einfluss auf dessen tektonische Gestaltung,
der sich vornehmlich in seiner, durch die starken doppelten Epistylien
aus Eichenholz motivirten, Weitsäuligkeit ausspricht. Wir müssen jedoch,
der auf Analogien begründeten Wahrscheinlichkeit gemäss, uns auch
diesen Holzarchitrav als bekleidet denken, gerade so wie nach Vitruv's
ausdrücklichen Worten die Balkenköpfe der Decke an ihren Stirnflächen
(in eorum frontibus) mit Antepagmenten verschalt waren, also nicht mehr
stofflich als Balkenköpfe erschienen, sondern ein fortlaufendes Gesimms,
eine Hängeplatte, bildeten.

Man hat die diese Balkenköpfe betreffende Stelle des Vitruvischen

Fall ist. Dieser Theil zeigt sich noch entschiedener als die anderen
dienenden Gefässtheile als ein Angefügtes, das durchaus nicht mit dem

Bauche aus gleichem Stoffe zu bestehen braucht, auch ursprünglich
nicht bestand. Die primitiven Töpferwaaren der Kelten, Germanen,

But let's carry on with our discourse. In 1893, in the introduction to *Stilfragen* (Problems of Style) in which he criticized Semper, among others, Riegl spoke of the exaggerated 'primal fear' that gave rise to ornament.[9] In the Loos of the articles we are discussing, that fear, or rather that precaution with regard to ornament exists, just as it existed in Semper. It is clear, therefore, that whether it is understood as a necessary consequence of technique and material or understood in its classical purity, the ornament that Loos has in mind—his *possible* ornament—can only be terse. In perfect harmony with the theories of Semper, who never differentiated between artwork and craft, Loos makes no distinction between architecture and objects. However, the object of everyday use is in fact his battlefield of choice in these articles, and there, in the object, the 'fear of ornament', the terseness he requires of it is radicalized, so that the entire discourse is reduced to the form, the 'pure form' to which Loos himself refers. Of form, precisely, beautiful and determined by use, at the same time and necessarily, Loos speaks in another article from this period, 'Glas und Ton' (Glass and China),[10] quoting a long paragraph from the chapter devoted to ceramics in Semper's *Der Stil* (Style) [fig. 12]: 'these magnificent Greek vases,' says Loos, rhetorically affecting surprise, 'owe their form solely to naked utility', and thus they are practical, even if we had always believed they were merely beautiful.

Always following Semper, then, continually quoting and glossing him, while interpreting him in the sharp schematic version best suited to the public controversies he had ignited, Loos's discourse on ornament in these articles from the turn of the century belongs to an architectural tradition: it is obvious and logical. Logical, above all, when viewed from the standpoint of utility: Loos never tires of repeating that 'the modern spirit requires above all else that the utilitarian object be practical' and that this is one of the conditions of its perfection and beauty: 'since what is not practical is never perfect, neither can it be beautiful';[11] and obvious when viewed from the standpoint of its classical condition, which is a recurring presence in Loos's writings, like a sediment constantly disturbed by, among other things, the old concepts of *decorum*—that eternal insistence that the appearance of things and the effect of architecture should be consonant with their character—and of *concinnitas*, as when he concludes—without naming Alberti, but citing the 'old people of the *Cinquecento* (*sic*)', and after stating that 'the practical object in itself, in fact, is not beautiful'—that an object is beautiful when nothing can be subtracted from it or added to it without detracting from it.[12] When all is said and done, then, it is not enough that the object be practical: what can slip in through that crack? Not much, perhaps, but ...

fig. 12

Riegl, for whom ornament was the highest expression of the human spirit, born of an act of will, considered the Semperian tradition's theory of the material-technical origin of ornamentation 'dismal', and accused Semper's followers of 'fanaticism'.[13] Clearly that is the tradition to which, in terms of will and principle, Loos belongs—and who could doubt the fanaticism of Loos! Let's say, then, that Loos writes as a fanatic at the extreme limit of a dismal tradition. But I repeat: for all that, have we at any point seen these articles criminalize ornament or demand its summary disappearance on account of its degeneracy? No.

With a view to tieing up any loose ends, let's look at a detail that could call my argument into question. In 'Das Luxusfuhrwerk' (Luxury Carriages),[14] another of the *Neue Freie Presse* articles from 1898, Loos wrote: 'The lower the cultural level of a people, the more extravagant it is with its ornament, its decoration. The Indian covers every object, every boat, every oar, every arrow, over and over with ornaments. [...] The Indian says: this woman is beautiful because she has gold rings in her nose and her ears. The person at the peak of humanity says: that woman is beautiful because she does not have rings in her nose or ears.' Many years later, in 1931, when Loos included this article in his book *Trotzdem* (Nevertheless), he added a footnote here: 'The first salvo in the struggle against ornament'.[15] From the vantage point of 1931 we understand what Loos means: how he wants retro-actively to *re-signify* those lines. And it is true that for the first time here he refers to ornament as characteristic of the 'lower' peoples, in contrast to the tendency of civilized societies to dispense with it. But that characterization of the primitive or the savage as a compulsive ornamenter of any surface, from their own skin itself to the most trivial utensil, and the inevitable opposition of this to the sobriety of European civilization, sometimes implicit and at other times explicit, sometimes with moralizing intentions, as in Loos, and in many other cases simple observation, had for long been a commonplace, to be found in travel books, in evolutionary theories, in treatises on style and in histories and studies of the origins of art. What Loos wrote here can be read, in different words, both in Charles Darwin's assertion of the 'notorious' 'passion' for ornament, appreciated above all by the 'savage races',[16] and in such popular nineteenth-century treatises on ornamentation as *The Grammar of Ornament* by Owen Jones, in which the lengthy first section, entitled 'Ornament of Savage Tribes' [fig. 13-16], opens with the assertion that there is no people, 'in however early a stage of civilization, with whom the desire for ornament is not a strong instinct'.[17] A number of years later, in 1894—contemporary, then, with the writings of Loos, and in the same cultural environment—Ernst Grosse published *Die Anfänge der Kunst* (The Beginnings of Art),[18] a book that proved both highly

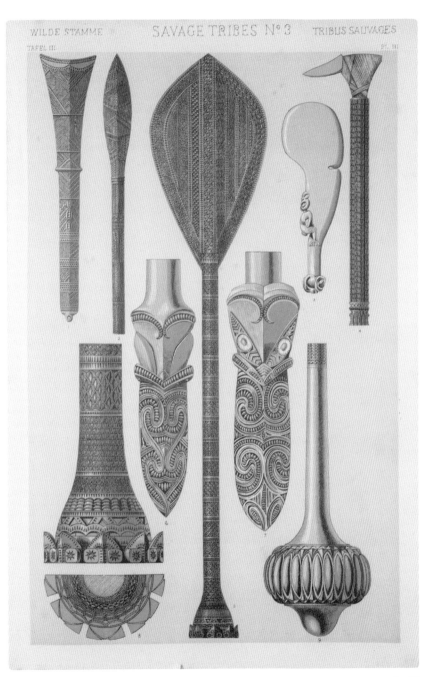

fig. 13

decoration of the rude tent or wigwam to the sublime works of a Phidias and Praxiteles, the same feeling everywhere apparent : the highest ambition is still to create, to stamp on this earth the impress of a individual mind.

From time to time a mind stronger than those around will impress itself on a generation, and carry with it a host of others of less power following in the same track, yet never so closely as to destroy the individua ambition to create; hence the cause of styles, and of the modifications of styles. The efforts of a people in an early stage of civilisation are like those of children, though presenting a want of power, the possess a grace and *naïveté* rarely found in mid-age, and never in manhood's decline. It is equally so in the infancy of any art. Cimabue and Giotto hav not the material charm of Raphael or the manl power of Michael Angelo, but surpass them both in grace and earnest truth. The very command of means leads to their abuse: when Art struggles, i succeeds; when revelling in its own successes, it a signally fails. The pleasure we receive in con templating the rude attempts at ornament of th most savage tribes arises from our appreciation of a difficulty accomplished; we are at once charme by the evidence of the intention, and surprised a the simple and ingenious process by which the resul is obtained. In fact, what we seek in every work o Art, whether it be humble or pretentious, is th evidence of mind,—the evidence of that desire t create to which we have referred, and which al feeling a natural instinct within them, are satisfie with when they find it developed in others. It i strange, but so it is, that this evidence of mind wil be more readily found in the rude attempts a

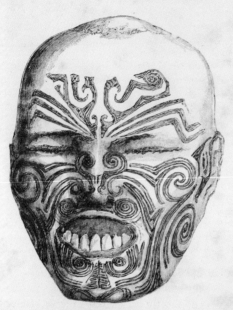

Female Head from New Zealand, in the Museum, Chester.

ornament of a savage tribe than in the innumerable productions of a highly-advanced civilisation. Individuality decreases in the ratio of the power of production. When Art is manufactured by combine effort, not originated by individual effort, we fail to recognise those true instincts which constitute it greatest charm.

Plate I. The ornaments on this Plate are from portions of clothing made chiefly from the bar of trees. Patterns Nos. 2 and 9 are from a dress brought by Mr. Oswald Brierly from Tongotabu, the principal of the Friendly Island group. It is made from thin sheets of the inner rind of the bark o a species of hibiscus, beaten out and united together so as to form one long parallelogram of cloth, which being wrapped many times round the body as a petticoat, and leaving the chest, arms, and shoulder bare, forms the only dress of the natives. Nothing, therefore, can be more primitive, and yet the arrangement of the pattern shows the most refined taste and skill. No. 9 is the border on the edge of the cloth; with the same limited means of production, it would be difficult to improve upon it. The patterns are formed by small wooden stamps, and although the work is somewhat rude and irregula in execution, the intention is everywhere apparent; and we are at once struck with the skilful balancing of the masses, and the judicious correction of the tendency of the eye to run in any one direction by opposing to them lines having an opposite tendency.

14

popular and highly influential; indeed, in its thinking and its examples it influenced Loos. Grosse claimed that the first ornament was body painting and tattooing, and among the paradoxes he posed 'Western civilization' was this: if we consider it absurd for African women to pierce their lips and ears to wear large hoops, how should we regard the pierced ears of our sisters? What of the earrings made to celebrate the Jubilee of the Queen of England?[19] But enough of these parallels. In fact, what interests me here is the way Grosse puzzles, in evident perplexity, over that primitive 'instinct' and that primitive 'passion' for ornament, on how he reflects on the enormous quantities of energy expended in artistic creation and how he puts forward the essential question of the non-utility of art in its very origins—and, again, when he writes that 'great art' is not a pleasant pastime but an essentially 'uncomfortable' effort, isn't there something that is familiar to us as readers of Loos? But back to business. Grosse said that the primitive peoples are precisely those 'incapable of distinguishing between the superfluous and the necessary', and added—somewhat incredulously—that natural selection should 'long ago have caused those people who squandered their energy in an activity so devoid of objectives to disappear, in favour of other peoples endowed with a more practical bent.'[20] He goes on to say, however, that had that happened, art would never have come to be 'as elevated and rich as it presents itself now'. I am struck by Grosse's claim not only because it identifies art, or ornament, with waste, and a practical talent with their absence, but also because it introduces into this question the issue of evolution, or, literally, natural selection. Certainly, as I said, Grosse seems perplexed as he tries to find in the passion of savage peoples for ornament, or art, a reason that would square with that evolutionary law, while authors like Semper or Riegl had simply denied any relationship: for the former, because ornament arose from the specific material and technical requirements of each situation, and for the latter, exactly the opposite, because 'the need for decoration'—or *horror vacui*, as he writes a few lines below—'is one of the most elementary human needs, more elementary than the need to protect the body' and originated in a 'decisive artistic will'.[21] It is worth recalling Riegl's tremendous diatribe in the first chapter of *Stilfragen* against Darwin, or more precisely, against those—such as Haeckel—who had popularized Darwin's theories, and even more against those who tried to apply them to the field of art history, who for Riegl are none other than Semperian 'materialists', vulgar popularizers of Semper.[22] When, for example, in 'Das Sitzmöbel' (Furniture for Sitting), an article to which we have already referred,[23] Loos says that 'nothing in nature is superfluous', he would seem to be making a place in his considerations for Darwinian theories, but is it necessary to recall that, for Darwin, the quantity and diversity of ornaments that exist in nature, wasteful from a physical point of view,

fig. 14

27

fig. 15

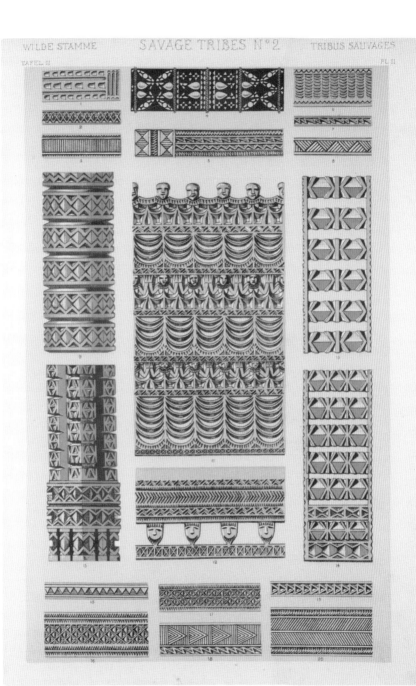

fig. 16

useless from a practical point of view and uncomfortable from the point of view of survival, always represented precisely a way to call into question and even of repudiating the idea that in nature 'nothing is superfluous'? Is it necessary, in short, to recall the famous example of the peacock's tail? And that is not all: after the words just quoted, when Loos goes on to assert comparatively, but now in Semperian terms, that 'the beauty of a practical object can be determined only in relation to its function', is he not now going 'beyond' Semper, like one of those 'materialists' criticized by Riegl: in other words, one of those who may be said to *tone up* the architectural theory of the technical and material origin of ornament with the more universal and enormously popular theory of the natural selection of species? In the paragraph from which we started—'the lower the cultural level of a people, the more extravagant it is with its ornament'—this justification and this mutual aggrandisement of the two theories of selection are manifestly present: Loos, indeed, introduces it by proposing to review 'a few chapters of the history of civilization', holds up for us the example of the Indian, and concludes, as we have seen, with the reference to 'the person at the peak of humanity'.

Given that this figure of the 'person at the peak of humanity' concludes Loos's first declaration of the selection of ornament as cultural evolution, we must inquire into it. Without leaving 1898 and the articles for the *Neue Freie Presse*, we can start with a quote from 'Wanderungen durch die Winterausstellung des Österreichischen Museums' (Strolling around the Winter Exhibition in the Austrian Museum)[24]. It reads: 'The constitutional state has done away with all differences of class, but they persist among the people as an unwritten law. Aristocrats are granted a higher position, and the fact that people strive to achieve that higher position can only be explained by Darwin's law of development of the human race.' And also without leaving 'Darwinism'... As in nature, one law also holds in society, which is seen by Loos as a hierarchical, uniform whole, directed upwards. But what interests me now is not so much the care Loos takes to avoid mixing his ideas about society and culture with class conflict but rather the fact that in order to do so he has to shift them into the only realm in which this 'peak of humanity' can possibly be recognized as such without contradictions: the material world. Is it not with this that the great German sociologists of the time, Simmel and Sombart, were engaging or were soon to engage? With luxury or with fashion, of which Simmel said that, as a novelty, it 'affects only the upper strata' or that it is 'a product of class division,' or, more literally still, from the tyrannical view of evolution, so easily and deceptively applicable: 'Fashions are always class fashions, by the fact

that the fashions of the higher strata of society distinguish themselves from those of the lower strata, and are abandoned by the former at the moment when the latter begin to appropriate them.'[25]

On one side we have the Loos who writes about the places of private life, about the home, about the *intérieur*; the Loos who says: 'your home will make itself with you and you with your home' and, even more clearly, 'tastes can be argued over'[26] (precisely one of the stock phrases most hated by the aristocratic intellectuals of the century, starting with Nietzsche, who identified it with 'the plebeian, the democratic desire for the art of pleasing everyone',[27] although Loos, to be fair, is talking not about art but about 'your home'). On the other side we have the Loos who writes about public behaviour and, ultimately, about fashion, as I have said, or about etiquette. This is where the kind of aristocratizing evolutionism implicit in the quote contracts into absurd axioms along the lines of 'The fact is, for the man of high culture, linen is uncomfortable'[28] and attitudes such as that recalled by Fritz Wittels in his memoirs, where he remarks that Loos stopped speaking to him when he discovered that he fastened his shirts not with buttons but with pearls 'à la Hoffmann',[29] or into seemingly outrageous claims, as in the article in *Der Architekt* that we discussed above, where after asserting with absolute seriousness—and even with a Nietzschean touch, as we saw—that the 'architect of the future will be a classicist' he goes on to add, unperturbed, that 'the architect of the future must also be a gentleman'.[30] We need only bear in mind the realms in which Loos moved as a professional architect—the decoration of interior and the construction of fashionable shops, and particularly outfitters—to perceive at once the strategic value of these apparently odd sallies: however, there is far more to the matter. Let's look at a very significant issue: the way in which Loos preferentially and insistently identifies the 'peak of humanity' with the 'fashionable gentleman', and thus—ironically, or not so ironically, as in Semper's theory of the origin of ornament—for Loos clothes are a major concern in terms of definition [fig. 17-21]. Time and again in these early articles Loos reiterates the notion that being well-dressed should not draw attention to oneself at the centre of culture, that one's clothing is modern if, at the centre of culture, at a certain occasion, among the **best** society, it attracts minimum attention (1898), that the answer to the question of how one should dress is in the modern way, and that when one is dressed in the modern way one does not call attention to oneself. 'An article of clothing is modern, when it is possible to wear it in one's native cultural environment at a certain occasion in the *best* society and it does not attract any unwarranted attention' (1903),[31] etc.

31

Although we will not attempt to explore such an important issue in depth here, it will do no harm to point out how that idea of Loos's of not calling attention to oneself shifts at a certain point into the concept of 'uniformity' or of 'mask', which he defines as the form 'in which individuality may contain its richness in the best possible way',[32] an idea that evidently comes from Simmel, who identified among the various qualities of fashion its function as a *'pièce de résistance* adopted by sensitive and peculiar persons, who use it as a sort of mask'.[33] No less Simmelian is the related idea, which becomes increasingly evident in Loos, of the rootlessness of the city-dweller.[34] But that is the Loos of 1908 or 1910, the Loos who is already lecturing and writing about 'ornament and crime'. So let us go back to our present focus. Without further complication, then, what is the source, *in primis*, of this fixation, this repeated injunction not to draw attention to oneself at the centre of the best society? To discover it we need only glance at the literature of nineteenth-century dandyism, from Baudelaire—who comments, apropos the Salon of 1845, on the 'patrician gravity and dandyism that mark the chiefs of these powerful tribes [of Native Americans]'[35]—to Balzac, who writes in *Treatise on Elegant Living*, for example, in a manner perfectly familiar to readers of Loos, that 'the lavishness of the decoration is detrimental to the effect', or 'the boor covers himself, the rich man or the fool adorns himself, and the elegant man gets dressed', etc, etc[36]—and beginning, of course, with the most esoteric interpretations of Barbey d'Aurevilly,[37] to cite only the most significant. At the same time, given Loos's anglophilia, why not go to the origins, to Brummell, or better yet, under the circumstances, to the enormously popular biography of Brummell by Captain William Jesse? There we repeatedly encounter, expressed in different ways, the idea that a presentable appearance should not necessarily attract attention and learn that 'one of [Brummell's] aphorisms [was] that the severest mortification a *gentleman* could incur was to attract observation in the street by his outward appearance'.[38] I have spoken elsewhere about the characteristic double figure of the turn-of-the-century architect, at once bohemian in being a dandy and a dandy in being bohemian.[39] Loos's attitude is perfectly in line with this behaviour, and coincides specifically with that of the faction which affected to look down on the bohemian—although, in the play of appearances, fashion actually disputes their influence: Simmel criticized those who sought to 'soar above the mass' by adopting 'banalities of a critical, pessimistic and paradoxical kind'[40]—in order to laud the dandy. Allow me to repeat the point again: for all their prejudices, did dandies criminalize ornament and condemn it to disappear on account of its degeneracy? No. Did Loos, as a dandy? No.

It is clear that Loos did not need to wrestle with Riegl's doubts or with Grosse's scruples, or—for the time being—with Simmel's criticisms: the inflection indicated by all of these quotations from his earliest articles (though it has to be said that in purely material terms his writings between 1897 and 1908 account for more than half of his total output of theory) between a discipline-centred discourse—materials, techniques, tools, utility ...—and a popular discourse—the law of the selection of species, of adornments, of cultures ...—and, finally, a yet more mundane discourse— dandyism, fashion, etiquette, luxury...—is, once again, perfectly consistent with his polemical purposes and with the public medium in which they are deployed: the general press. But despite all this, despite this inflection, I ask again: has Loos criminalized ornament? Has he classed those who use it as criminals? Has he condemned it to extinction for its degenerate character? No.

Well then, when does such a thing first occur? In an article entitled 'Damenmode'[41] (Ladies' Fashion). The tone in which we have thus far seen Loos treat questions of ornament, whether in reference to architecture, to utilitarian objects or to 'gentlemen's fashion'—with regard to which this article on 'ladies' fashion' seem to be the logical pendant—changes radically. In fact, more than the tone, what changes are the sources and the strategy of Loos's critique. In previous texts in which he addressed these issues, he did so from within the discipline itself—a theory of architecture, the object and ornamentation determined by a specific tradition—or from within their respective languages—that of the dandy, for example. We look in vain in 'Damenmode' for recommendations on how to dress properly in the best modern society, still less for concrete advice on the various Viennese tailors, or their 'fear of the public' as compared to the English, or comments on their specialties: Ebenstein's demidress or coaching coat with pearl buttons, Keller's Norfolk jacket, Goldman & Salatsch's Kaiserjäger uniforms hunters squad, among many others.[42] No: 'Damenmode' says nothing about fashion, dressmakers or clothing; instead it analyzes *woman*—her character, her psychology—from the conviction that, as Darwin had written and so many others had repeated at that end of a century, with Cesare Lombroso first among them, 'the male gives the variety; the female, the species'.[43] This view, translated to other spheres, would be encapsulated in one of Max Nordau's more notorious asseverations: 'Woman is as a rule typical, the man individual.' A reading of 'Die Herrenmode' (The Gentlemen's fashion) and 'Damenmode'—no article in the second title—seems to show that this was Loos's motto. We will come to Lombroso and Nordau in due course, but for now let's be clear that

fig. 17

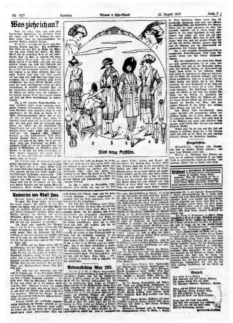
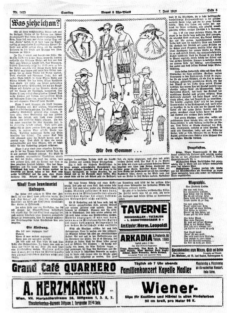
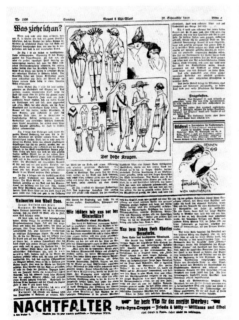
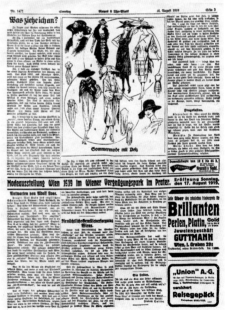

fig. 18, 19, 20, 21

Loos here is not writing from within the discipline—from theories of ornament—or in the language of fashion but from elsewhere: his jargon now derives from medical sexology and criminal anthropology. There had been signs: in one of his first articles he had compared the pretensions of bourgeois furniture with 'the distinction of the *cocotte*',[44] but that was no more than a cliché — a cliché of the double standards of bourgeois taste, precisely. Better still, when he first wrote about the savage's obsession with ornament, what did he use for comparison but earrings, worn alike in the ears of women of the 'lower' and of the civilized peoples? It is in terms, then, not of 'ladies' fashion' but of female psychopathology that Loos—far removed from any disciplinary discourse—first identifies ornament and crime. From Krafft-Ebing to Freud, a whole world—precisely in Vienna—could be invoked here and tell it to elucidate Loos's seemingly sudden turn against 'ladies' fashion'. But it would better to descend a little from these heights. Let us consider the apocalyptic opening lines of Loos's article, reminiscent of the language of the psychelyptic novels of the time: 'Ladies' fashion. You disgraceful chapter in the history of civilization! [...] Whenever we peruse your pages [...] we hear the cry of abused children, the shrieks of maltreated wives [...] Whips crack, and the air takes on the burnt smell of scorched human flesh [...]' and so on. It is worth recalling here that around the turn of the century, Viennese intellectual circles (and not only intellectual but also police circles, of course) took a keen interest in the erotic curiosities of the city's *demi-monde*. A single detail: reviewing the 'deviations' that define and accompany women's fashions—'Sacher-Masoch, Catulle Mendès, Armand Silvestre [...] *le cul de Paris*'—Loos arrives at what is virtually their ultimate expression: 'The child-woman came into fashion.' The child-woman may be a more or less forgotten figure nowadays, but she was a red-hot topic—indeed, a meme: at once concealed and commented on, hidden from view and hugely popular—in intellectual circles in *fin de siècle* Vienna and revived, as we know, by Surrealists like Dalí at the end of the twenties. Loos mentions Peter Altenberg, known for his love for young girls, and the difficulties with the law in which that love embroiled him, and indeed Loos himself was denounced much later, in 1928, for 'corruption of minors', although for us here that is a separate question. There is a much *denser* version of the one that concerns us now, the child-woman, in the complicated relations between Karl Kraus and his young lover, Irma Karczewska. It was on the basis of this case that Fritz Wittels developed the 'concept', so to speak, of the child-woman, of a precocious uninhibited sexuality, which he first presented in a talk to the Vienna Psychoanalytic Society entitled 'Die grosse Hetäre' (The Great Hetaira) and subsequently published as 'Das Kindweib' (The Childwoman) in Kraus's magazine

following pages fig. 22, 23

Die Fackel in 1907.[45] Wittels traces the advent of the eternal bride with the appearance of a young girl, which, according to him, corresponds to the female character of the modern age, when women no longer want to be worshipped as Juno and still less as Demeter, goddess of fertility, since they are more attractive to men if they renounce motherhood to play the game of being the eternal child. The article's references to the smile of the Mona Lisa and to Correggio's 'angel girls', or to the artists' position in relation to the kind of love dispensed by the tyrannical, capricious, unattainable and barren woman, an actress who imitates everything and a 'mistress of sadism', are clear indication of its popular superficiality. The members of the Vienna Psychoanalytic Society did not consider it a serious contribution to psychoanalysis, and the Society's journal referred to it only in a brief footnote, while for Freud, the child-woman described by Wittels was nothing but a 'perfect rogue'.[46] The article was accepted, however, for newspaper publication in *Die Fackel*, and this is what matters to us here: its popular status and dissemination. What does Wittels's article do, after all, but publicize with a scientific air in a popular periodical with a well-deserved reputation for controversy—here we have the crucial combination—all of the characteristic prejudices, clichés and stereotypes of the *femme fatale*, or in this case the *fille fatale*, of the *fin de siècle*? These are the protagonists of this story: Loos's friend Karl Kraus and Fritz Wittels, Kraus's friend and Loos's doctor. The high and the low: the same pseudoscientific, controversial, popular tone is common to all three, especially when the subject is 'female psychopathology', the most frisson-charged topic of the era.

But there is something even more concrete in Loos's article that is of specific interest to us: 'female psychopathology' is placed in relation here to an issue that until this moment had been treated essentially in disciplinary terms, namely ornament. Needless to say, women's erotic passion for ornament is one of the recurring themes of 'medical sexology' and 'criminal anthropology'. From Lombroso and Ferrero, for example, who in *La donna delinquente* (The Criminal Woman) offer numerous examples [fig. 22-27]—all presented in documentary and statistical fashion, sometimes drawn from police medical files; sometimes from literature, to which they always accord the status of scientific evidence; sometimes from popular sayings, etc—of women who 'have become killers to obtain a necklace' or 'to have pretty hats',[47] to, among many others, Gaëtan Gatian de Clérambault, who lived and worked in Vienna at the turn of the century and from his position as a physician of the Prefecture of Police in Paris wrote a number of celebrated articles, collected in the exemplary *Passion érotique des étoffes chez la femme* (Erotic Passion for Fabrics in Women).[48]

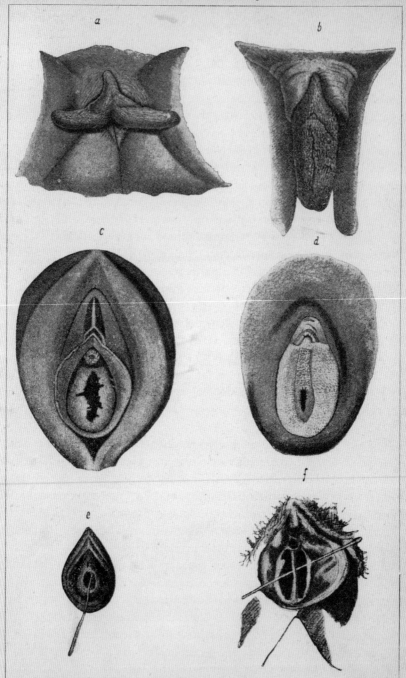

ANOMALIE VULVARI IN OTTENTOTTE (*a, b*)
ED IN EUROPEE (*c, d, e, f*).

a, b) Grembiule od ipertrofia delle piccole ninfe di Ottentotte (Blanchard). — *c*) Imene frangiato in vergine (Hoffmann). — *d*) Imene cribrato (Hoffmann). — *e*) Imene peduncolato (Miriewsky) o a campanello. — *f*) Imene septato (Hoffmann).

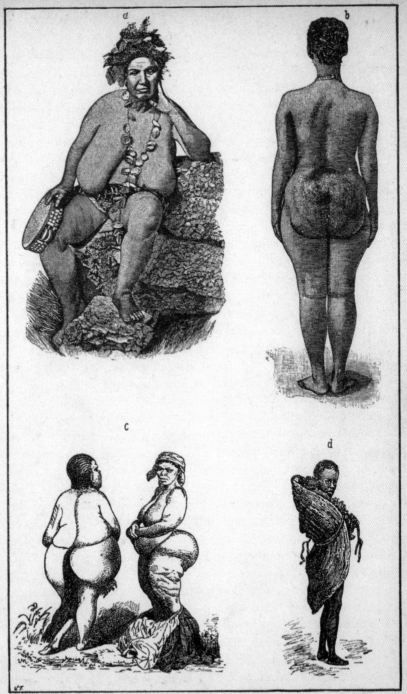

POLISARCIA IN ABISSINA.
CUSCINETTO POSTERIORE IN AFRICANE.

a) Ballerina o prostituta Abissina (Ploss), tipo di polisarcia africana. — *b)* Ottentotta con cuscinetto posteriore (Ploss). — *c¹)* Donna Bongo (Schweinfurth). — *c²)* Donna Koranna con cuscinetto posteriore e ipertrofia delle natiche e delle coscie (Ploss). — *d)* Donna selvaggia che porta un bambino sul dorso, come in tutti i popoli primitivi (Ploss).

Having mentioned *The Criminal Woman*, let us pause to consider it for a moment. This book was very popular at that time when Loos wrote 'Ladies' Fashion', and I think it is no exaggeration to say that his article seems in large part to be a synopsis of it. I shall not linger here over Loos's reflections, following the opening mentioned above, on love in animals and man, insisting on the complicated, unnatural and cyclical nature of the human sensibility, especially that of women. It is true that a glance at Lombroso and Ferrero's chapters on 'Love among Animal Species' and 'Love among the Human Races' would suffice to show where those ideas came from, but that would be too generic. More specific is the way that Loos goes on to emphasize, alongside the 'most grandiose martyrdoms' imagined by the Marquis de Sade, the cruelty which emerges from the 'same root' implicit in the simple killing of a flea by a 'candid pale girl': is not this a somewhat comical but exemplary compression of what Lombroso and Ferrero assert with great pomp in the sections they devote to female cruelty and female pity? Women, they begin by saying, quoting Spencer, are as barbaric as men, and their failure to commit the same atrocities is due to their powerlessness, and the chapter concludes with the claim that despite their pity, which is nothing but an atavism linked to the maternal instinct, every woman has a vein of cruelty.[49] But that is not enough: it still seems generic. We can go further, and be more literal. Loos dedicates the crux of his article to elucidating the sexual significance of female dress and adornment. He first affirms that the origin of dress is not prudery about the naked body—'You have been told that modesty imposed the fig leaf on women. What a lie! Modesty, that painful sentiment constructed by a refined culture, was unknown to primitive men'—and goes on to say that 'the awakening of (man's) love is the sole weapon that women possess in the battle of the sexes' because the only way for a woman to acquire social standing is 'by marriage, through (the position of) the man [...] whether she had formerly been a princess or a *cocotte*', so that women are obliged to appeal to male sensuality by means of their clothes; and finally, that 'from what has been said it follows that the direction of gentlemen's clothing is in the hands of those that occupy the highest social position, while the direction of ladies' fashion is exercised by the woman that displays the greatest sensitivity in awakening sensuality: the *cocotte*'; and further, that '[the] clothing of the woman is distinguished externally from that of the man by the preference for ornamental and colourful effects and by the long skirt that covers the legs completely [...] [demonstrating] that woman has fallen behind sharply in her development in recent centuries. No period in culture has witnessed so great a difference in the clothing of the free man and the free woman. In past epochs, the man also wore colourful and richly decorated clothing whose seams reached to the ground. The grandiose advancement that has taken hold of our century,' Loos concludes, 'has happily overcome ornament.'

following pages fig. 24, 25

Let's look now at the arguments of Lombroso and Ferrero in *The Criminal Woman*. The section entitled 'Modesty', for example, begins by stating that 'nudity is the rule among primitive people'[50], but even before that, the chapter on 'Love among the Human Races', we are treated to a lengthy consideration of this question. 'Civilization,' write Lombroso and Ferrero, 'engendered modesty when it suppressed nudity' so that, contrary to common belief, the wearing of clothes had its origin not in modesty but in the need to arouse sexual attraction, and thus its first expressions are body painting, tattooing and showy ornaments: 'the coquetry of women,' they say, 'did the rest.'[51] But let us go on. In the section devoted to female cruelty, our authors describe the looks of hatred exchanged by two women who casually encounter one another: 'The reason for this duel,' they conclude, 'is not difficult to comprehend if we think of the struggle of grace, beauty, elegance and coquetry, linked not only to their vanity, but also to the sole purpose of their existence, matrimony.'[52] In many other parts of the book, Lombroso and Ferrero reiterate this claim, supporting it with a multitude of examples. But what is of most interest to us now is how the claim is developed in the chapter on 'Vanity'. *The battle of the sexes*, they write time and again in different ways, 'has become the major occupation of women', and is manifested especially 'in dress'. Clothes, they continue, 'are of greater importance in the battle of the sexes than physical beauty, so that women come to believe that their clothes are part of their body'.[53] Not only that: women in the upper strata of society, they say, quoting Mme. de Maintenon, have 'more luxury than taste',[54] failing as they do to remember that clothes and adornments are especially associated with criminal women, a class that evidently includes *cocottes* (the full title of the book is, as I recall, *La donna delinquente*, and, underneath in a smaller typeface, *la prostituta e la donna normale*—The Criminal Woman, the Prostitute, and the Normal Woman), to the extent that 'a passion for dress is a characteristic of the born criminal', as is 'excitation over expensive and almost sacred objects'.[55] But we can go further. What are women's clothing and adornments like? 'Women,' our authors tell us, 'exhaust gold, silver, silk, flounces and diamonds to adorn themselves: they never feel satisfied, they never feel that the price is high enough'[56]; and: 'At the present time, in dress, in ornament, in customs, women retain many atavistic remnants. In Europe [...] they still wear bracelets, earrings, necklaces [...] which are the last vestiges of the primitive *toilette*. In order to show off their earrings, women submit themselves to mutilation, piercing their ears.'[57]

Lombroso and Ferrero, then, and this is essential to Loos's reasoning, assign to ornament, characteristic of women, an atavistic significance that, as a primitive vestige, is contrary to progress.

DONNE DI GENIO EUROPEE E AMERICANE.

FISIONOMIE DI CRIMINALI RUSSE.

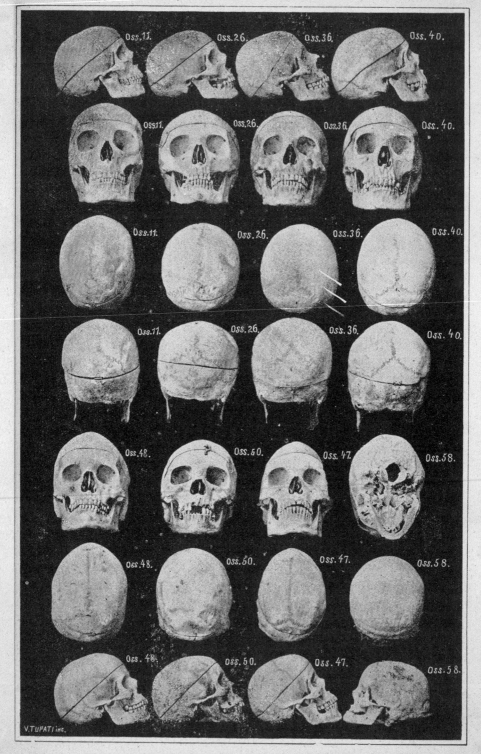

CRANII DI CRIMINALI ITALIANE.

On this basis they develop their theory of women's fashion as evidence of female 'misoneism', which is 'psychological and organic, in that she represents conservation in the evolution of the species'.[58] In short, Lombroso and Ferrero's book interprets women's fashion as a form of hatred of and resistance to progress and a constant regression of the past. They write, for example: 'Fashion is a proof of the misoneism of women, who are unable to distinguish between important and trivial innovations. Indeed, all of the innovations of fashion are, almost always, nothing but exhumations of previous trends.'[59] Max Nordau, in books like *Entartung* (Degeneration), deploys similar arguments, but we will come to that in due course. Let us conclude for now, with the result of all of this. 'It is a proven fact,' Lombroso and Ferrero write, 'that as civilization increases, man becomes less concerned about dress, while woman attaches more importance to it'; and: 'With the advent of civilization, the vanity of men started to decline, while that of women began to grow.' Given that 'it is in the clothing, on the exterior, that vanity is concentrated',[60] need we continue?

The reader will excuse this cascade of quotations: we could have opted, in the style of Lombroso's summaries, to arrange them in two columns. Point by point, Loos's arguments follow the reasoning of *The Criminal Woman*: evidently, then, addressing the issue of ornament has nothing to do with the theoretical traditions of architecture or with the language of fashion based on the habits of bohemians and dandies. In this article—none other than an article on 'women's fashion'—Loos has changed his register, and the one he uses here could not be more pseudoscientific or, in its time, more morbid, more populist, more popular: that of criminal anthropology.

When Loos writes: 'The lower the cultural level of a people, the more extravagant it is with its ornament [...] The Papuan and the criminal adorn their skin. The Papuan covers his boat with ornaments,' he apologizes rhetorically, saying 'Here I must repeat myself', and directs the reader to the *Neue Freie Presse* article discussed above, in which he tells us that the Indian 'covers every object, every boat [...] with layer upon layer of ornament'.[61] Admittedly there, as we have seen, he connected the obsession with ornament with barbarians and savages, but we have also seen how that notion arose from a commonplace of evolutionary theories, travel books, art history and the treatises on ornamentation. Here, instead of repeating himself verbatim, Loos changes register: the Papuan and the criminal who 'adorn their skin' have nothing to do with the Indian who decorated his boat. Furthermore, these are new *characters* in his writing.

fig. 26

N. 1.

N. 3.

N. 2.

N. 5.

N. 8.

N. 7.

N. 9.

N. 11.

FISIONOMIE DI CRIMINALI

fig. 27

N. 6.

N. 10.

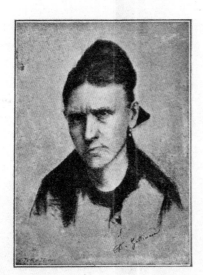

N. 13.

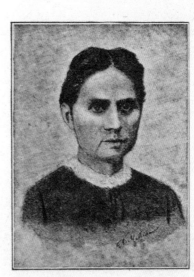

N. 14.

M, TEDESCHE ED ITALIANE.

The Papuan, for a start, mentioned here for the first time, represented in *fin de siècle* Vienna a far more familiar 'savage' than the exotic Indian: much of the Naturhistorisches Museum was filled with the collection of Maori art donated by Andreas Reischek, an Austrian ethnographer who had travelled in New Zealand; more importantly, the scene of the last German colonial adventure had been (and still was) New Guinea, and references to Papuans and Maoris abounded in popular books and the general press in German, which made no very fine distinctions between them. The criminal, too, is associated here for the first time, like the savage, with ornament. Even more interesting: what do the criminal and the savage do? Do they decorate both oars and their boats, their objects? No, they ornament their skin. Also for the first time, then, tattoos are mentioned.[62] Papuans, criminals and tattoos: these are the three essential pillars of 'Ornament und Verbrechen', of the theory of modern *disornamentation*. To pause for a moment over tattoos, then, cannot help but be instructive, especially from the point of view I wish to emphasize: the shift in Loos's language from the *interior* of the architectural discipline of ornament to the *exterior* of the language of criminal anthropology.

There is no need to stress how, from the moment of its discovery (from the testimony of Captain Cook's naturalist, Joseph Banks), the tattoo was associated by explorers, anthropologists and historians of culture and art with the savage peoples' 'passion' for ornament, and even interpreted, with remarkable unanimity, as a primal form of art. But we can adjust our focus, directing it at the disciplinary discussion closest to Loos. In *Der Stil*, Semper focuses on the tattoo as a primary form of surface ornamentation [fig. 28-32]. However, these geometric designs drawn freehand on the skin did not fit well with his theory of the technical origin of ornament, in which abstraction necessarily emerges out of the warp and woof of the original fabric. Faced with this paradox, Semper put forward two far from conclusive explanations: the first is that these naked primitive people, without textile techniques, who tattoo their skin, had in former times possessed crafts they had since forgotten, or had had contact with other, more technically advanced peoples, from whom they had copied that form of decoration; the second is that, fundamentally, tattoos and other forms of body ornamentation always adapt to underlying bone and muscle structures, thus bearing witness to their dependence on the technical and the material. Riegl's response to such speculations—and not only to Semper's—constitutes one of the most assertive passages of his *Stilfragen*.[63] Referring to Maori art—of which the Naturhistorisches Museum (as we know, and he reminds us) had an 'important and instructive' collection—Riegl focuses on one of the essential motives in the ornamentation of that 'primitive realm of art',

Fassen wir dagegen die Spirale als geometrisches Kunstgebilde, hervorgebracht auf dem Wege rein künstlerischen Schaffens, im Sinne unserer Ausführungen im ersten Capitel S. 24. Wir fragen alsdann nicht nach Naturerzeugnissen oder Produkten technischer Kunstfertigkeit, welche zur Erfindung des Spiralenmotivs geführt haben mochten, sondern nach der nächst einfacheren geometrischen Form, aus welcher die Spirale im Wege künstlerischer Fortbildung hervorgegangen sein konnte. Unter den planimetrischen Grundmotiven steht ihr der Kreis am nächsten. Der Kreis ist das vollkommenste aller planimetrischen Gebilde, er erfüllt das Postulat der Symmetrie nach allen Seiten hin. Dies allein

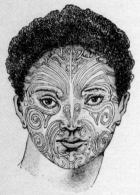 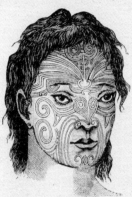

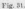

Fig. 31. Fig. 32.

würde schon genügen den Umstand zu erklären, dass der Kreis weitverbreitete Anwendung in den geometrischen Stilen gefunden hat. Die Gliederung des Kreises erfolgte am vollkommensten durch seinesgleichen, in koncentrischer Richtung, durch eingeschriebene kleinere Kreise oder durch Betonung des Mittelpunkts. Setzte man Kreise unter einander mittels der Linie in Verbindung, so war das Element der Tangente geschaffen. Koncentrische Kreise, durch Tangenten verbunden, stehen aber dem einfachen Spiralenband (Fig. 25) in der äusseren Erscheinung bereits sehr nahe: wollte man dieselben mit einem fortlaufenden Zuge hinzeichnen, so brauchte man bloss die Tangente in den äusseren Kreis,

gramm der k. k. Staats-Unterrealschule zu Graz 1892: Die Spirale in der dekorativen Kunst.

fig. 28

die Maori vor Zeiten, bevor sie auf Neuseeland isolirt wurden, den Gebrauch der Metalle gekannt; denkbar wäre dies immerhin. Aber dann müsste weiter ein sehr beträchtlicher Zeitraum verflossen sein, wie wir ihn für das Zustandekommen einer so festgeschlossenen „Steinzeit"-Kultur unbedingt voraussetzen müssen.

Angesichts der vielen durch sei es stabilen, sei es zufälligen Handelsverkehr vermittelten Beeinflussungen, die es uns in der Regel so schwer machen an den Kunstübungen primitiver Völker das wirklich Autochthone, Uraßgekommene von dem Hinzugetragenen durch Mischung Er-

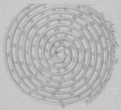

Fig. 29.
Theil eines durchbrochenen Gitterschnittes der Maori.

zeugten zu scheiden, ist es schon ein ungeheurer Gewinn ein Gebiet zu überblicken, das vermuthlich seit Jahrtausenden eine von Aussen unberührte, ganz selbständige Entwicklung genommen hat[20].

Da ist es nun von grösstem Interesse zu sehen, dass in der Ornamentik der Maori die Spirale eine überaus massgebende Rolle spielt. Sie findet sich da in Holz mittels Kerbschnitt eingearbeitet, dann in Holz durchbrochen, so dass man ein Metallgitter vor sich wähnt (Fig. 29), ferner in nussartige Fruchtschalen gravirt (Fig. 28), wo sich die Spirale

[20]) Vergl. die Notiz über Neuseeländische Ornamentik in den Mittheilungen der anthropologischen Gesellschaft in Wien 1890, S. 84 ff. Hieraus unsere Figg. 28, 29, 30.

Mittels der Spirale lassen sich aber auch ganze Flächen in zusammenhängender Weise verzieren. Ein einfacheres Beispiel zeigt Fig. 26. Zu Grunde liegt das Spiralenschema von Fig. 25, fortwährend neben einander wiederholt, aber so, dass die Einrollungen immer im Gegensinne gewechselt, d. h. bei der einen Spirale rechts, wenn die benachbarte Spirale sich links einrollt. Das übrige besorgen die vegetabilischen Zwickelfüllungen, die aber nicht wie in Fig. 25 in die Zwickel, welche die einzelnen Spiralen an sich tragen, eingefügt sind, sondern in die Zwickel, welche die Einrollungen von immer je zwei

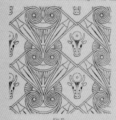

Fig. 27.
Flächenmusterung mit Spiralen, zwickelfüllenden Lotos und Rosetten.

benachbarten Spiralen in Folge ihrer Annäherung an einander bilden. In diesem Falle sind also die Lotusblüthen nicht mehr blosse Zwickelfüllungen, sondern sie dienen zugleich dazu, um die Verbindung zwischen den einzelnen Spiralen und damit ein zusammenhängendes Muster über die ganze Fläche hinweg herzustellen. Dass aber diese erhöhte Bedeutung der vegetabilischen Motive innerhalb des Spiralenschemas nicht die ursprüngliche ist und nach wie vor das geometrische Spirale als das Hauptmotiv dieser Art von Flächenverzierung ansehen müssen, lehrt uns das einfachere Beispiel Fig. 26.

Ein noch reicheres Beispiel bietet Fig. 27. Die einzelnen Kreiseinrollungen sind hier in mehrfacher Weise untereinander verbunden, so

9. Das Aufkommen des Akanthus-Ornaments.

kann, übrigens nicht der Grazie entbehrenden Fabulirens — in völlig unverkennbarer Weise ausgedrückt, und ich glaube kaum, dass es irgend ein Forscher in neuerer Zeit unternommen haben möchte, ihre Stichhaltigkeit ernsthaft zu vertreten. Furtwängler hat auch schon (a. a. O. S. 9) ausdrücklich darauf hingewiesen, dass die erste Auftreten des Akanthus nachweislich an Palmetten-Akroterien erfolgt ist,

Fig. 111.
Korinthisches Kapitäl vom Lysikrates-Denkmal. Nach Jacobsthal.

zu einer Zeit, da ein korinthisches Kapitäl bisher noch nicht nachgewiesen werden konnte. Brückner scheint der gleichen Meinung zu sein, da er (a. a. O. 82) sogar die Gründe nennen zu können glaubt, welche dazu geführt hätten, den Akanthus an den Akroterien der Grabstelen anzubringen. Dass aber das eigenthümliche ausgezackte vegetabilische Motiv, das ein so charakteristisches Merkmal des korinthischen Kapitäls ist, in der That gemäss Vitruv's Berichte auf eine unmittelbare Nachahmung der Acanthus spinosa zurückgeht, daran hat

bandförmig glatt von dem schraffirten und durch den eingedrungenen Schmutz geschwärzten Grunde abhebt, endlich in Stein eingegraben und dann öfters von eingeschlagenen Punkten begleitet (Fig. 30). Diese Spirale erweist sich als nächstverwandt mit der altegyptischen durch den Umstand, dass sie sich, wie oben, in kreisförmigem Schwunge erst ein- und dann vom Mittelpunkte wieder herausrollt. In den grossen Seitenfüllungen der Canoes (Fig. 28) beschreibt jede Kreuzspirale eine grössere Anzahl von Windungen, bis im innersten Mittelpunkte die ein- und die ausrollende Spirallinie aneinander absetzen; man sehe aber an derselben Figur die äusserste Windung rechts, wo die eingeschnittenen

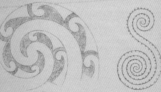

Fig. 28. Fig. 30.
Gravirung auf einer Fruchtschale der Maori. Gravirung an einem Holzruder der Maori.

Spiraleinrollungen bloss durch Tangenten untereinander verbunden sind; also im Wesentlichen das altegyptische Schema von Fig. 25. Diese selbe Windung stellt ein schmales Bordürenband dar: die Zwickel, welche die Einrollungen mit den Rändern des Bandes bilden, sind durch dreieckige Figuren oder durch gebrochene Stäbchen ausgefüllt. Hierin äussert sich also vollends der enge Zusammenhang mit Fig. 25, nur dienen an letzterem Beispiele vegetabilische Lotosblüthen zur Zwickelfüllung, während an der neuseeländischen Schnitzerei zu diesem Zwecke gemäss dem ausschliesslich geometrischen Charakter dieser Ornamentik blosse Linienconfigurationen herangezogen erscheinen.

Es gilt nun zu untersuchen, ob die Ausbildung der Spiralornamentik bei den Neuseeländern in einer mit der altegyptischen nahe

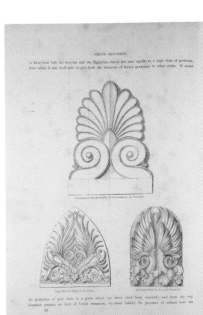

fig. 33, 34, 35, 36

the spiral, which 'is found in fretwork and in carved wood ..., worked in fruitbowls in the form of a walnut ... carved in stone ... on the sides of the great canoes ...' and so on. Materialist theories, Riegl explains, have always thought of the spiral as deriving from the coiling of a threadlike material—wire, yarn (as Semper claims), leather thong—but among the Maoris, he continues, there is neither metalworking nor textiles, and what is more they 'incomprehensibly' choose hard materials, wood and stone, 'to incise, with great effort, spiral ornaments with their obsidian tools'. Now, where are the 'most delicate and artistic' spirals in Maori art? Where the material to be decorated offers least resistance: on the skin itself, which, Riegl insists rhetorically, 'has nothing to do with metal or with weaving'. The tattoo, then, is for Riegl the supreme proof that the spiral, as a geometric form repeatedly present in the ornamentation of all primitive and ancient peoples, has its origin not in material and technique but in 'pure artistic creation' [fig. 28-40].

As we know, Riegl's *Stilfragen* appeared in 1893, shortly before the publication of Loos's articles. That Loos could be described from Riegl's point of view, as we saw, as a 'Semperian materialist' would not have prevented him from appreciating these compelling arguments in an area as topical and, it would seem, as interesting to him as the primitive art—he had so much to say about Papuans—in the collections of the Naturhistorisches Museum in Vienna: the spiral, the vortex, is one of the obsessive images of ornamentation that is capable of covering anything, and without leaving the museum or art history Riegl also speaks of canoes and decorated human skin. But evidently such disciplinary issues, at least in this field, are no longer of interest to Loos. Other interferences have impinged on his considerations, and in the case of the equation linking savages, criminals and tattoos, these are very clear. From the first beginnings of criminal anthropology, born out of large-scale 'scientific' operations of monitoring and control of the masses by medicine and the police in the second half of the nineteenth century, tattoos became one of the main indicators used in the cataloguing, classification and identification of marginal or criminal populations and of those even suspected of belonging to them. The tattoo was recognized as characteristic of certain occupations—sailors, soldiers...—but also, and above all, of criminals, and indeed, like a dog chasing its own tail, the great surveys of tattoos, such as those directed by Alexandre Lacassagne, whose results were published in 1881, were conducted in barracks, ships and prisons, and never among the general population. Furthermore, the fact that its distant origins were to be found, as we have seen, in the savage and primitive peoples made tattoo the most characteristic and all but symbolic form of atavism, a concept derived from the Haeckel of recapitulation theory as a kind of recondite

latent heritage that reveals itself in certain beings as a trait resistant to evolution, a theory that criminal anthropology applied to society in order to identify human types that resist civilization and progress. In Lombroso's highly popular book *L'uomo delinquente* (The Criminal Man), the tattoo is manifestly present as a sign of atavism and a mark of criminality, but even more interesting in this light is his somewhat later *Palimsesti del carcere* (Prision Palimpsests), a book devoted to what he calls the 'pictographic' obsession of criminals and other outsiders — the mentally ill, for example. Lombroso starts by saying that in prison all of the surfaces speak by way of the graffiti that the prisoners scrawl 'on the walls, on the jars, on the wood of the beds, in books provided with moralizing purposes, in the paper medicines are wrapped in, in the sand scattered on the floor of the galleries, on their clothes ...'.[64] For Lombroso, all of these scribbles, these hieroglyphics, these drawings, these more or less crude writings spreading over every surface and addressing every subject are far more eloquent than any statement a criminal may make to the police. Their 'graphomania', then, prompts criminals to speak, we could say, through ornament [fig. 43-50]. But Lombroso cannot avoid relating these drawings to primitive graffiti or to children's drawings: his conclusion is clear, and he insists on it time and again in his book: 'The tendency of criminals to express their thought [...] by means of figures is a curious fact of atavism';[65] 'The criminal uses and abuses hieroglyphics [...] which are truly reminiscent of the era of primitive languages';[66] 'The atavism of the graffito is amply demonstrated by history' and confirmed by the 'children's pastime' of scribbling on walls;[67] 'These signs amount to something between painting and writing, as occured in the beginning with hieroglyphs',[68] and so on. In any case, 'the oldest and perhaps the most widespread graffito was the tattoo' and if the pictographic passion of the criminal, his graphomania, actually extends to all surfaces, 'the most numerous series of simple pictographs is provided by tattoos',[69] in which the criminal 'paints his entire history on his skin'.[70] Thus, when in 'Damenmode' he gives us the Papuan and the criminal who 'adorn their skin', Loos is not in fact reiterating, as he says, but going a good deal further than the point he had reached in his previous ruminations on ornament. But with all these quotes, I have not yet recalled a phrase that figures in the same text, and one that Loos emphasizes: 'Convictions under paragraphs 125 to 133 of our criminal law represent the most reliable of fashion *journals*.' No other sentence reflects so clearly the shift in Loos's position with regard to ornament: far removed from any disciplinary discourse, far beyond the language of bohemians and dandies, in this text he criminalizes it, and also criminalizes those who use or manufacture it — and criminalizes them in advance. When he mentions the savage, the criminal and tattooing together, he does not do so for nothing; nor does he when he relates

fig. 37

fig. 38

The ornaments in the woodcuts below and at the side show a far higher advance in the distribution of curved lines, the twisted rope forming the type as it naturally would be of all curved lines in ornament. The uniting of two strands for additional strength would early accustom the eye to the spiral line, and we always find this form side by side with

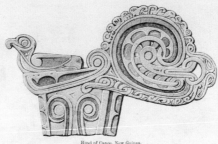

Head of Canoe, New Guinea.

geometrical patterns formed by the interlacing of equal lines in the ornament of every savage tribe, and retained in the more advanced art of every civilised nation.

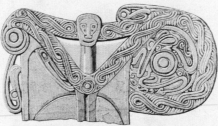

Head of Canoe, New Guinea.

From the Side of a Canoe, New Zealand.

The ornament of a savage tribe, being the result of a natural instinct, is necessarily always true to its purpose; whilst in much of the ornament of civilised nations, the first impulse which generated received forms being enfeebled by constant repetition, the ornament is often-times misapplied, and instead of first seeking the most convenient form and adding beauty, all beauty is destroyed, because all fitness, by superadding ornament to ill-contrived form. If we would return to a more healthy condition, we must even be as little children or as savages; we must get rid of the acquired and artificial, and return to and develope natural instincts.

The beautiful New Zealand paddle, Nos. 5–8, on Plate III., would rival works of the highest civilisation : there is not a line upon its surface misapplied. The general shape is most elegant, and the decoration everywhere the best adapted to develope the form. A modern manufacturer, with his

16

fig. 39

stripes and plaids, would have continued the bands or rings round the handle across the blade. The New Zealander's instinct taught him better. He desired not only that his paddle should be strong, but should appear so, and his ornament is so disposed as to give an appearance of additional strength to what it would have had if the surface had remained undecorated. The centre band in the length of the blade

Handle of a Paddle.—B. M.

is continued round on the other side, binding together the border on the edge, which itself fixes all the other bands. Had these bands run out like the centre one, they would have appeared to slip off. The centre one was the only one that could do so without disturbing the repose.

The swelling form of the handle where additional weight was required is most beautifully contrived, and the springing of the swell is well defined by the bolder pattern of the rings.*

Club, Eastern Archipelago.

* Captain Cook and other voyagers repeatedly notice the taste and ingenuity of the islanders of the Pacific and South Seas ; instancing especially cloths, painted " in such an endless variety of figures that one might suppose they borrowed their patterns from a mercer's shop in which the most elegant productions of China and Europe are collected, besides some original patterns of their own." The "thousand different patterns " of their basket-work, their mats, and the fancy displayed in their rich carvings and inlaid shell-work, are, likewise, constantly mentioned. See *The Three Voyages of Captain Cook*, 2 vols. Lond. 1841–42; DUMONT D'URVILLE's *Voyage au Pole Sud*, 8vo. Paris, 1841 ; Ditto, *Atlas d'Histoire*, fol.; PRICHARD's *Natural History of Man*, Lond. 1855; G. W. EARLE's *Native Races of Indian Archipelago*, Lond. 1852; KERR's *General History and Collection of Voyages and Travels*, London, 1811–17.

fig. 41

atavistic beings such as the criminal, the savage and the woman with adornments. In all truth, then, what Semper or Riegl had to say about tattooing or about the ethnographic collections of the Naturhistorisches Museum must have meant very little to Loos.

However, in 1898, when Loos's output of theory was at its peak, among all of the articles we have mentioned, this reference to the tattoos of savages and criminals, this recourse to criminal anthropology to speak of women, this criminalization of ornament and its bearers makes 'Damenmode' the exception. The other texts, despite the spirit of controversy, the indignant attitude and the heated language, are positioned, albeit disproportionately, in the realm of ornamentation or fashion: however extreme and original, they are, as we know, the writings of an architect or a dandy. In fact, Loos does not mention tattoos again until late in 1907, almost ten years later, in an article published in the form of a private *tract*: a short guide to visit his own works titled 'Wohnungswanderungen' (Walks to visit homes).[71] Here again he speaks of the 'Indian ornamental frenzy of these self-appointed cultural barbarians' and just before it is written: 'Whatever our applied artists, prompted by the survival instinct, might say, for people of culture a face without a tattoo is more beautiful that one with a tattoo, even if designed by Kolo Moser [fig. 41] himself.' Loos repeats himself, as he acknowledges and as he recalls in this very text, but for those familiar with the language of biological evolution or criminal anthropology—and these were popular subjects, as we know—that 'survival instinct' ascribed to Vienna's applied artists, including Kolo Moser, is a direct declaration of their atavism and thus of the need for their disappearance. In fact, in the previous paragraph Loos was even more obvious: 'Only people who, although born in the present, are in fact living in a previous century, such as women, peasants, Orientals (including the Japanese) and mutilated brains such as the designers of ties and rugs are still creating even today new ornament.' As Lombroso had made sufficiently clear in his books, and as everyone therefore knew, women, peasants, Orientals—and Lombroso never fails to stress that he specifically includes the Japanese whenever he mentions Orientals—and the mentally ill are atavistic beings. Loos has only to repeat the claim and add 'designers' to the list to criminalize them immediately. Ultimately it is for this, for their condition as *monsters* atavistically resisting progress, that they are judged and condemned: and for this reason, too, in accordance with the arguments of biological evolution and medical criminologists, that they must disappear.

fig. 42

DEGENERATION

BY

MAX NORDAU

Translated from the Second Edition of the
German Work

FIFTH EDITION

NEW YORK
D. APPLETON AND COMPANY
1895

TO

PROFESSOR CÆSAR LOMBROSO,
TURIN.

DEAR AND HONOURED MASTER,

I dedicate this book to you, in open and joyful recognition of the fact that without your labours it could never have been written.

The notion of degeneracy, first introduced into science by Morel, and developed with so much genius by yourself, has in your hands already shown itself extremely fertile in the most diverse directions. On numerous obscure points of psychiatry, criminal law, politics, and sociology, you have poured a veritable flood of light, which those alone have not perceived who obdurately close their eyes, or who are too short-sighted to derive benefit from any enlightenment whatsoever.

But there is a vast and important domain into which neither you nor your disciples have hitherto borne the torch of your method —the domain of art and literature.

Degenerates are not always criminals, prostitutes, anarchists, and pronounced lunatics; they are often authors and artists. These, however, manifest the same mental characteristics, and for the most part the same somatic features, as the members of the above-mentioned anthropological family, who satisfy their unhealthy impulses with the knife of the assassin or the bomb of the dynamiter, instead of with pen and pencil.

Some among these degenerates in literature, music, and painting have in recent years come into extraordinary prominence, and are

The diminishing of the need for ornament as culture progresses is an old theme in Loos, as it is, of course, in the Semperian tradition, and not only there but also in any rationalist tradition. But once again, this question is being transformed in a direction *external* to those traditions. Loos writes, as in one way or another he had done before, that a modern person is no longer in a position to employ an ornament, but he now adds, with special emphasis: 'The incapacity of our culture to create a new ornament is a sign of its greatness.' Loos is not speaking here of the ornament of the time, as he did in those articles from 1898 to which he so often refers, but of a necessary *disornamentation*. We have already mentioned on several occasions Max Nordau, a contributor, like Loos, to the *Neue Freie Presse*, and one of the most widely read and translated polemicists of turn-of-the-century Europe. Now, the disappearance of art with the progress of civilization, its unnecessity, is one of the key themes of Nordau's hugely popular book *Entartung*, dedicated to none other than Cesare Lombroso [fig. 42], who in turn dedicated the 1897 edition of *L'uomo delinquente* to Nordau. 'As for the future of art and poetry,' Nordau writes, 'it can be clearly foreseen [...] That which was originally an occupation of men fully developed intellectually [...] is slowly but surely being transformed into a minor pastime and ultimately into a children's game.' And after listing a number of examples, from dance to the novel, in support of his claims, he concludes: 'art and poetry will become pure atavism, and will be practiced only by the more emotional sectors of the population, namely women, young people, even children.'[72] While it is true that Loos is speaking not about art—although he considers it to be something radically separated from life—but about ornamentation, the arguments are identical. For example, when on more than one occasion he holds up as an example for his time the assertion that the Romans were so advanced that they had no need to invent a new order of column, do we not hear an echo of Nordau's claim that the history of art teaches us that in three thousand years we have not been able to find new formulas?[73] Being able or not is no great cause for concern to Nordau, who in any case concludes that 'the aberrations of [contemporary] art have no future';[74] nor to Loos, who, as we have seen, identifies the greatness of his time with its 'incapacity' to create a new ornament rather than with its 'will' to do so or not, to return here to the concept of the 'will to art' that Riegl was elaborating in those same years precisely out of the study of artistic periods regarded as decadent, such as the late Roman. But it is not this contamination that interests Loos, and without leaving *Entartung*, we can go further: Nordau repeatedly says that since art has not always existed we may, without hypocritically rending our garments, start to think that with the advance of civilization it could in fact cease to exist again—indeed, not *could* but *should*, because he goes on to affirm that 'aesthetic fashions are the result

of the mental illness of degenerates and hysterics'.[75] So, he continues, if scientific criticism—such as he claims to practice—has shown that artists bear the 'stigmata' (the signs not only mental but also physical that can be discovered both in their bodies and in their clothes, in the objects they use and in their customs) of degeneration and madness, and that art is therefore 'an unhealthy activity', should we not apply the same remedies to them as we do to other degenerates? Faced with the degenerate artist, Nordau believes, we must have the courage to exclaim 'He is a criminal!', and in the presence of his work: 'It is a disgrace to my country!'.[76] In fact, from the very beginning of his book, in the dedication to Lombroso, Nordau states his intentions with absolute frankness. Addressing Lombroso, he declares that 'Degenerates are not always criminals, prostitutes, anarchists and pronounced lunatics; they are often authors and artists'.[77] Nordau also argues that the creation of an aesthetic school is exactly the same as the forming of a criminal gang,[78] and that the artist's degenerative stigmata can easily be recognized and must be denounced: 'The degenerates babble and stammer instead of talking. They utter monosyllabic screams instead of constructing sentences that are grammatically and syntactically structured. They draw and paint like children who with useless hands dirty tables and walls. They mix together all artistic genres and lead to the primitive forms they had before evolution differentiated them. Every trait in them is atavistic, and we know that atavism is a sign of degeneration. Lombroso has shown that many of the characteristics of criminals are atavistic.'[79] Now, let's combine these words with the definitions of atavism put forward by Lombroso in *L'uomo delinquente*: 'Thus far we have looked for atavism in the materiality of the crime. It is said, for example, that murder, robbery and other crimes are normal actions in savage life, and reappear through atavism in civilian life [...]'[80] and so on. Perhaps it is time to quote the famous second paragraph of 'Ornament und Verbrechen':[81] 'The child is amoral. So is the Papuan, to us. The Papuan kills his enemies and eats them. He is no criminal but if a modern man kills someone and eats him, he is a criminal or a degenerate. The Papuan tattoos his skin, his boat, his rudder, his oars; in short, everything he can get his hands on. He is no criminal. The modern man who tattoos himself is a criminal or a degenerate.' Are many more arguments or major exercises of exegesis necessary to comment on such analogies? It is enough to note them, because what is obvious is that the means Loos adopts to hammer home the need for the disappearance of ornament and the strategies he uses to discredit 'our applied artists', criminalizing them, feminizing them or dismissing them as 'mutilated brains'—to confine ourselves to the tract of 1907—are the same. And there is more. Consider this verdict on the furniture of a modern apartment: 'Everything seems as if brought together by chance, in the

most heterogeneous way, without any semblance of unity; a well-defined historical style gives the impression of being old-fashioned, heavily provincial, and as for a style of its own, our time has not produced one.' And a few lines below, with specific reference here to the furniture and decorations exhibited at the Salon du Champ-de-Mars: 'If the director-general of Dante's *Inferno* had an audience-chamber, it might well be furnished with such as these. Carabin's creations may be intended to equip a house, but they are a nightmare.'[82] This is not Loos, but Nordau: this is his tone when writing about furniture, decoration and intérieurs, as he does at length in *Entartung*.

I have said that after its first appearance in 'Damenmode', Loos has no further recourse to the tattoo as a trope until his pamphlet of 1907. Among the titles of his articles of 1908 are 'Die Überflüssigen' (The Superfluous), 'Kultur' (Culture) and 'Kulturentartung' (Cultural Degeneration). Interestingly, the language used in these texts is not that of criminal anthropology or sociology, as it is in the two we have lingered over, 'Damenmode' and 'Wohnungswanderungen'. Not that he did not resort to it: references to the Papuan and his obsession with ornamenting everything he can get his hands on, or the modern preference for an untattooed face ('even if the tattoo originated from Michelangelo') recur, along with such rhetorical questions as 'Do we need "applied artists"?' and the answer: 'No'.[83] However, for the most part these reflections on clothing or on utilitarian objects are not far removed from those of 1898: we even find stories about the origin of modern dress in which there are still, ironically, reverberations of Semper's textile model or judgments on the habits that befit a gentleman. It is the titles, then, that reveal Loos's most recent preferences, and they light up with new tones those old judgments. And is it not striking that the popular and populist language of Nordau and Lombroso should be concentrated, as if it were a key, wholly in the titles? This is precisely the case: the texts point in one direction and the titles in another—up to a point, of course—because Loos wants to *attract attention*. Everything we have been talking about comes to a head in 'Ornament und Verbrechen', the longest text Loos had written at the time, in which arguments external to the traditions of architecture, decoration and fashion are finally deployed in all their aspects, and in which the title—peremptory, demagogic and populist—is in radical relation to the content. In other words, this is where Loos's discourse definitely alienates and commits itself.

The first paragraph of 'Ornament und Verbrechen', in which Loos sketches a parallel between the history of culture and human evolution from embryo to adult is a condensed version of Haeckel's theory of 'recapitulation': frequently cited by

Nordau, this theory holds that ontogenesis—the history of an organism's development—effectively recapitulates phylogeny — the history of the development of a species; the second paragraph, as we have seen, atavistically links the child and the savage, and associates the savage with tattooing and criminality, before concluding that the 'modern man who tattoos himself is a criminal or a degenerate'; the third and fourth speak of the 'graphomania' or 'pictorial' obsession of primitives and children and the erotic origin of the earliest 'graffiti'—the cross—before invoking the 'palimpsests' of public toilets as indicators of culture or degeneration; he then applies the law of atavism to ornament and its practitioners when he writes that stragglers 'slow down the cultural progress of nations and humanity; for ornament is not only produced by criminals; it itself commits a crime, by damaging men's health, the national economy and cultural development', bearing in mind, of course, that 'the modern ornamentalist is a straggler, or a pathological case', either 'a rogue or a degenerate', and so on, with the result that when, as the summation of all this, Loos writes rather too emphatically that 'I have discovered the following truth and present it to the world: *cultural evolution is equivalent to the removal of Ornament from articles in daily use*' and remarks that the world did not thank him, whom was he addressing? All or almost all of the arguments of 'Ornament und Verbrechen' are found in the most widely read works on biological evolution and criminal anthropology or sociology by Lombroso and Nordau, but it is certain that Loos was the first to apply them to architecture. Equally certain is that he was no longer talking about architecture, just as in 'Damenmode' he was no longer talking about women's fashions. And also certain is that in spite of everything, as we know, and although it does not talk about architecture, this is one of the most famous manifestos in the history of modern architecture, and the basis of Loos's theory of *disornamentation*. Or perhaps precisely because it does not talk about architecture, but exploits the same issues and the same language as the most morbid, demagogic populist propaganda—the most sinister and terrible—of the whole first half of the twentieth century, which by way of wars, mass persecutions and mass displacements was to culminate in the German concentration camps: atavism, disease, criminality, degeneracy ...

'Die Überflussigen', 'Kulturentartung' ...: illuminated from the perspective of events in European history just a few years after their publication, titles such as these in 1908 could hardly seem more baleful, nor the concept of the criminalization of ornament, of *disornamentation*, which emerged from the slogan of the third title, 'Ornament und Verbrechen', so dear to modern architecture, more fateful.

fig. 43 following pages 44 to 50

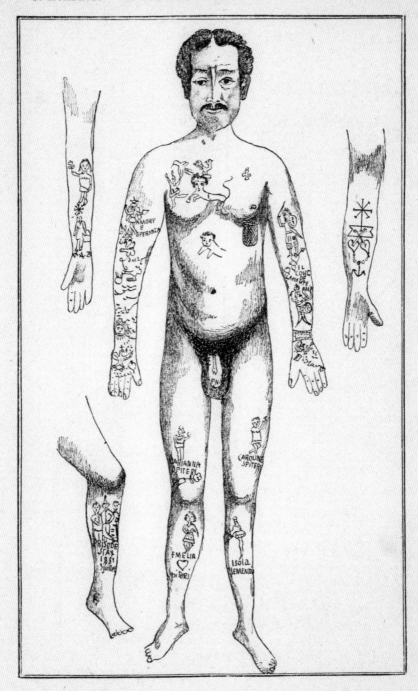

TATOUAGE SYMBOLIQUE D'UN VIOLATEUR, ETC.

CARMELE 1879
NANNINA 1881
DUNETTA 1881
LUVISA A ROSSA
1883

2

11

12

5

MARIA

1881 1781

BUSINA

Morte a
V.Z

13

7

10

Pl. XXXII.

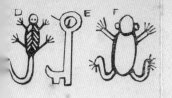

SEMPRE CHE CI E' VITA E
SPERANZA. CON QUESTO REVOL
VER SPARO ALL'AMBOLANZA
MIFIRMO E SONO
NARDO VINCENZO
1882

4

9

3

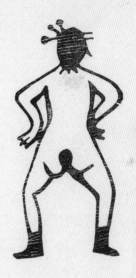

C.R

AFFERRETY Chisto c.c

6

RUSE
RINDO a chisso
MAZZO PERD
ETTI MI EZO
CAZZO

8

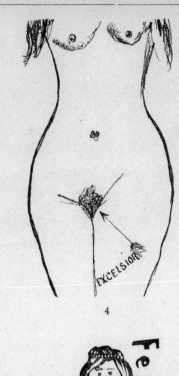

4

1

Pl. XXXIII.

2

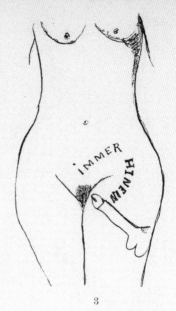

3

Ferelta

7

Speransella
Figurella
Tappia

5

6

ATOUAGES DE PROSTITUÉES.

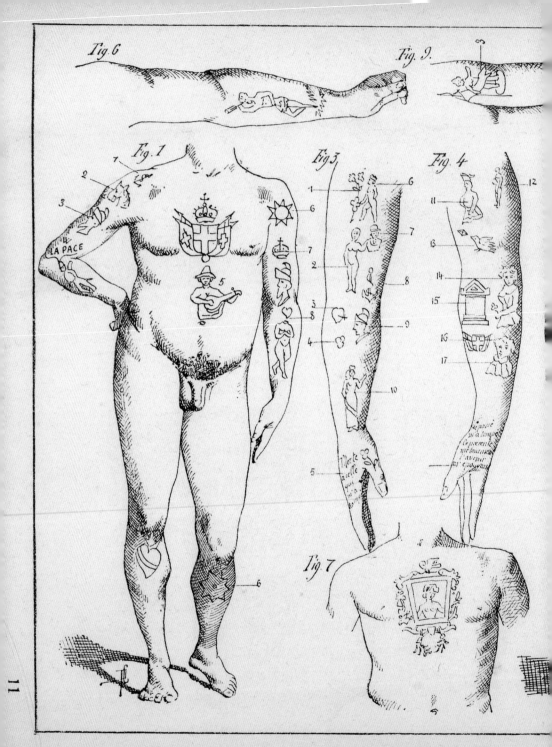

TATOUAGES

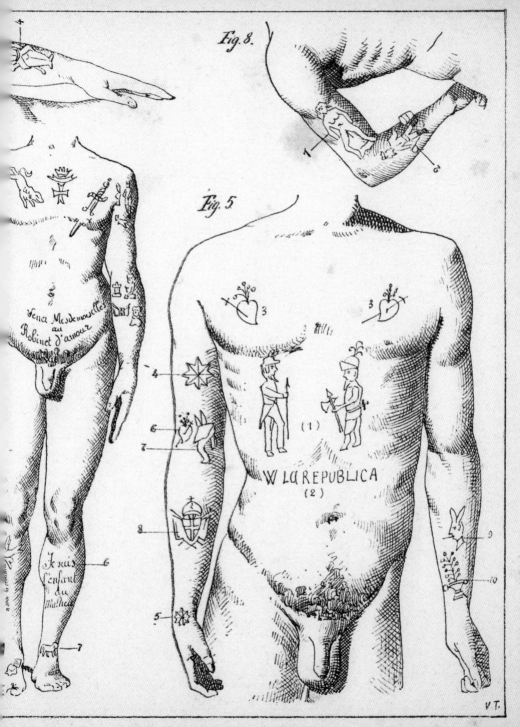

Fig. 8.

Fig. 5.

Sens Mesdemoiselle
au
Robinet d'amour

Je suis
l'enfant
du
malheur

W LA REPUBLICA
(2)

(1)

V.T.

CRIMINELS.

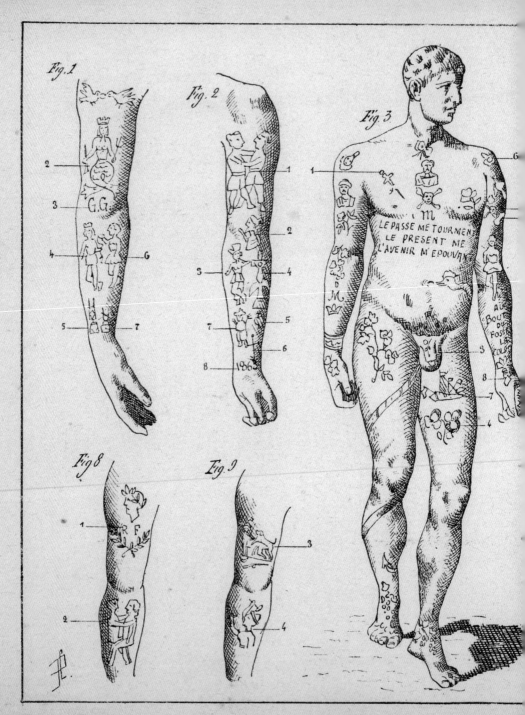

Fig.1

Fig.2

Fig 3

G.G.

LE PASSE ME TOURMEN
LE PRESENT ME
L'AVENIR M'EPOUVAN

1863

Fig 8

Fig 9

R F

TATOUAGES I

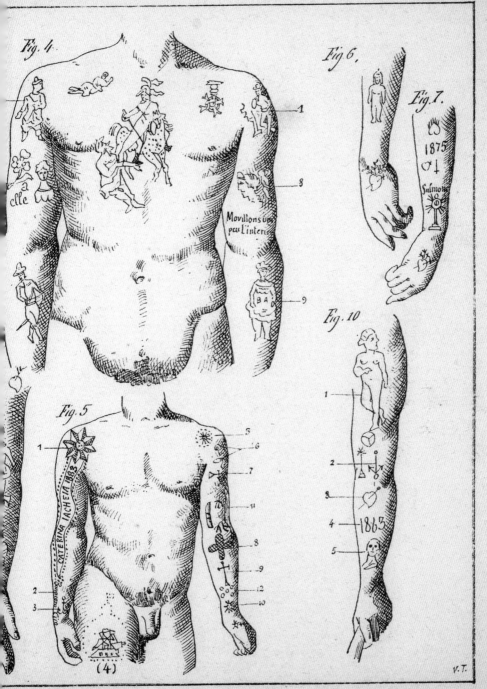

CRIMINELS.

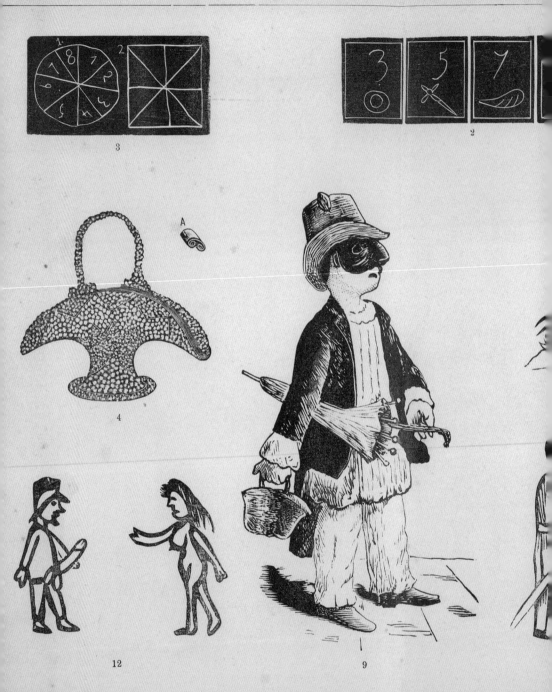

Pl. XLIV.

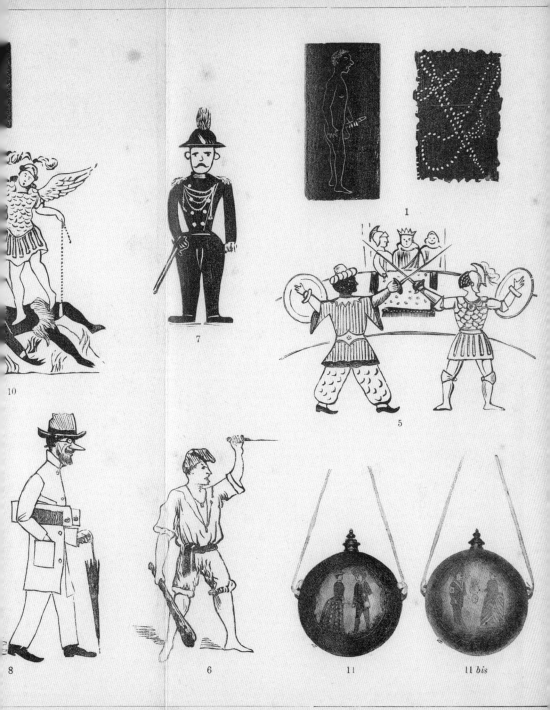

1

7

10

5

8

6

11

11 *bis*

merda alle carceri nove

IIO SONO
UN
DISCRAZIATO IL MIO
DESTINO E DI MORIR
IN PRIGIONE
STRANGOLATO

3 IANU
DU

I bis GOBDL
1887
AR

GIUSEPPINO INNOCENTE

POVER

LA LIBE

NON S

MERDA

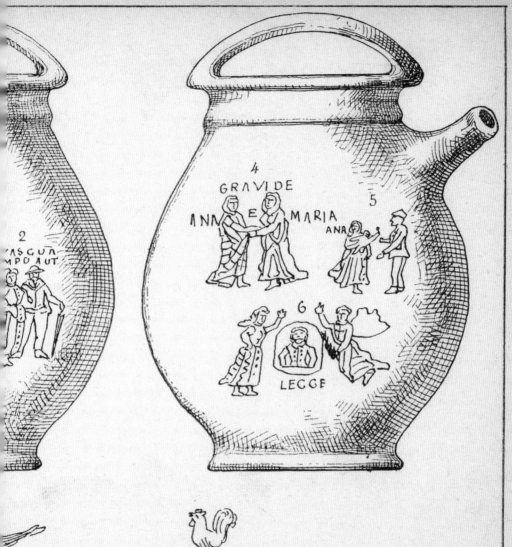

Pl. XXXV.

...RLI IN GABBIA GUESTO GALLO ANNUNZIA

...A PIANGI PER LA PICCIA, AUDISIO

...MAI STATO IN GUESTO CARCERE 1° A

...LE NOVE VIVA MI BECCO

...RIMINELLE.

VIA LARGA, ORE 3

NUM. 23 FARE

MORTE

(5)

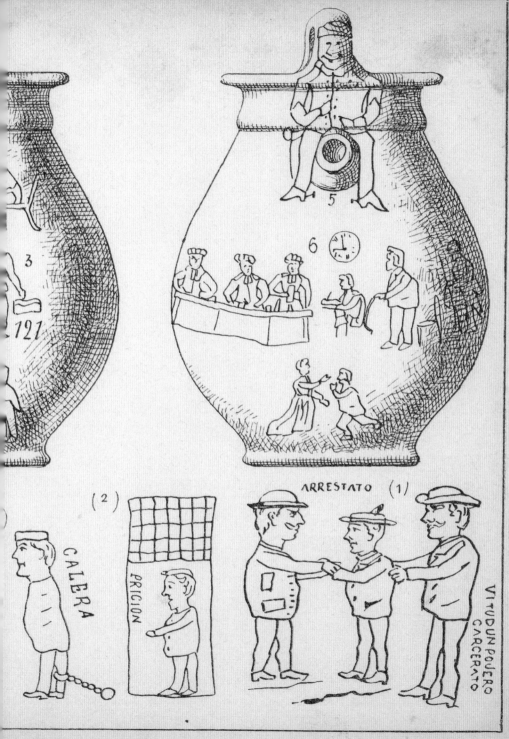

SPECIMENS of COMPOSITE PORTRAITURE

PERSONAL AND FAMILY.

Alexander the Great
From 6 Different
Medals.

Two Sisters.

From 6 Members
of same Family
Male & Female.

HEALTH.	DISEASE.	CRIMINALITY,

23 Cases.
Royal Engineers.
12 Officers,
11 Privates

6 Cases

9 Cases

Tubercular Disease

8 Cases

4 Cases

2 Of the many
Criminal Types

CONSUMPTION AND OTHER MALADIES

I 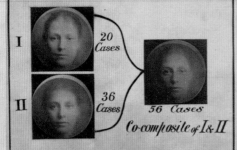 20 Cases

II 36 Cases

56 Cases
Co-composite of I & II

Consumptive Cases.

100 Cases

50 Cases

Not Consumptive.

fig. 51

In fact, we need only read the opening paragraph of the extraordinary book by Victor Klemperer, *LTI*, to understand what we are saying: 'New demands led the language of the Third Reich to simulate an increase in the use of the dissociating prefix *ent-* (de-) (though in each case it remains open to question whether we are dealing with completely new creations or the adoption by the common language of terms already familiar in specialist circles).'[84] There, in effect, between the need for the dissociating prefix and the specialist circles, it all locks down.

———

Well, then: let's 'recapitulate'.

In 'Ornament und Verbrechen'—as we by now know very well—culture is explained as an evolutionary process whose closest parallel is found in the development from embryo into adult; the atavistic image of the tattooed body is seen as best suited to conveying the intrinsic wickedness of ornament, and, finally, a taste for ornament is presented as a base pleasure that could only be felt by criminals or degenerates and unworthy of those superior individuals who alone are truly modern. On the one hand, then, culture as a biological process, as a selective screening in which the success of the fittest species—which, in a sinister circularity, are the fittest precisely because they succeed—inevitably entails the logical disappearance of the others, which are superfluous, and, on the other hand, the body—and its signs—as both the ideal palimpsest and the seat of the greatest impurity in which to monitor and correct deviations in that evolution. So however much Loos protested his case— 'I have discovered the following truth and present it to the world'—and however much architects were startled (or acted as if they were startled) by it, it is perfectly clear that those ideas would not have seemed very original in the early years of the twentieth century. Degeneracy and crime were the favourite words of figures such as Charles Darwin's cousin Francis Galton, Cesare Lombroso and Max Nordau, who also considered a large part of humanity to be superfluous.[85]

The fear and loathing inspired in Europe's elites and middle classes by the lower classes and the lumpenproletariat in an age of revolutions and mass migrations and the terrible scenario of the class struggle and the big city devoid of form were sublimated in the spectre of degeneration: there were indeed, those authors

said in their celebrated books, monsters among us in the shape of inferior beings who inhabited those infernos from which the end of mankind—or rather, of Western culture—was to be brought about through a colossal process of contamination. But our authors not only theorized degeneration and elaborated, as the good hygienists they were, those great metaphors of the disease that had to be cured at all costs, the cancer that had to be cut out; they also developed the *science* that would serve to identify beyond all doubt the degenerate. In effect, they saw in inferior beings (savages, or women, for example), in the diseased and criminal a series of physical features that were as perfectly classifiable as their tastes, their way of dressing or the objects they used. Atavisms, phenotypes: the scientific terminology of these authors always leads to the same ideas of fate and necessity. That atavistic beings should exist was inevitable, it was genetically determined; that they be identified, corrected or eliminated was a matter of necessity if the health of the species was to be restored and preserved. There were no two ways about it, and not much more to it. We know all of this all too well: the shape of the skull (our old friend phrenology), the brow ridges more or less pronounced, the forehead more or less bulging or short or sloping, the nose flatter or more aquiline, the lips more or less thick and fleshy, the ears protruding more or less prominently from the head, the hands and feet larger or smaller, the colour of the eyes (those with dark eyes far more degenerate than those with blue) and the hair (the darker, the more degenerate), the back more or less curved, the limbs shorter or longer and more or less loosely jointed, or more or less apelike ...: a very extensive catalogue could be drawn up as the basis for identification in every case. It would he hard to imagine a more thorough or more telltale form of *ornamentation* than that evidenced by the hereditary traits of the body. In the furtherance of his studies, which concluded in books with titles such as *Hereditary Genius* or *Natural Inheritance*,[86] Galton superimposed photographs of criminals: fourteen convicted murderers gave him the typical murderer's face. He also superimposed photographs of officers of the Royal Engineers: from these emerged, like an epiphany, the type of the healthy man, his health necessarily both physical and moral [fig. 51]. The faces were covered with indices, charts and numbers: the prostitute, the idiot, the siphilitic, the rapist, the savage, the primitive, the criminal, the Jew, all configured their own unit.

Lombroso, meanwhile, studied thousands of photographs from police files in researching his books (those we have seen and many others, like the significantly titled *L'uomo di genio* (The Man of Genius), whose purpose was to demonstrate the relationship between 'the idiots and criminals and the

individuals that represent the highest expressions of the human spirit', in which he asserted that 'the signs of degeneracy are more common among geniuses than among the mad',[87] and that many *fin de siècle* artists—Parnassians, Symbolists, decadents ...—have the stigmata of criminals and paedophiles, or are simply *mattoidi*—another of his successful coinages—or imbeciles. Of course, in strictly ornamental terms, the signs of such atavism—from primitive art to the art of the insane—are bizarreness, meticulousness, symbolism, a love of arabesques, uniformity of motives, absence of utility and so on. For Lombroso—whose theories of the pictographic obsession of criminals we have already reviewed—it was not just the lips, eyebrows, skull or hair colour that established beyond doubt the criminal or murderer, the rapist or prostitute but also the cultural products, the habits and the tastes of these inferior and degenerate beings were inextricably linked to their atavism and their criminal tendencies. Women, for example, (considered by Lombroso the most radical and subtle instance of degeneration and inferiority) and not only prostitutes or criminals are characterized, as we have seen, by their pathological love of ornament. While modern men, Lombroso tells us, have attained the apogee of culture in the renunciation of ornaments, which they regard as superfluous, and like to dress in discreet dark suits and in black and white, women feel an unhealthy love for prints and embroideries, for frills and feathers, for colours and jewels, for all that glitters, like children or savages. Ornament, in short, is for Lombroso one of the most visible signs of degeneracy and moral infirmity, and its origin, he adds, is erotic, neither more nor less than an attraction for the lowest styles of life, in which the passions of sexuality burn.

But it is not necessary to go back over these arguments and those of Adolf Loos in 'Ornament und Verbrechen' to see how all of this ties together: we already know, as we also know that for Galton, Lacassagne or Lombroso the tattoo constituted one of the things that infallibly characterized the criminal, or, more precisely, the tattoo was, as they all claimed to have proven statistically in prisons, the *ornament* of the criminal. For them it constituted on the one hand evidence of the insensitivity to pain of the bodies of the low, who were animalistic also in this respect, and on the other the most visible manifestation of one of the atavisms of the primitive or the degenerate: the tendency to self-mutilation, to do violence to oneself, and to cannibalism. In any case, the author who ensured that the arguments of those doom-laden experts on the moral and biological decay of humanity were converted directly into terrifying visions of the cultural decadence of the West was Max Nordau. Today Loos occupies a special place in the history of modern culture and

Nordau is forgotten, but, I must repeat once again, in the early years of the twentieth century Nordau was an important personage whose articles were translated and published in newspapers all over Europe while Loos was an unknown reader of Nordau—and a fervent and credulous reader, I would say.

But the fact that Nordau was carefully and systematically forgotten, or discreetly sidelined, as the case may be, does not mean that his theories ceased to be influential: the popular Haeckelian notion that ontogenesis replicates phylogeny, applied by Nordau to the history of civilization, converted into the idea that any cultural evolution or involution can be explained *naturally* in terms of a model of biological development permeated the entire European culture of his time and has even come down to our own time. We have already noted how the parallel that Loos draws in 'Ornament und Verbrechen' between human development, from embryo to adult, and the development of knowledge corresponds exactly to the biocultural summaries of Nordau: from bacteria to mammals, from the zygote to the nonagenarian, from the barbarous and primitive to modern man, everything can be explained in the same, perfectly parallel evolutionary terms. Nordau denounced Impressionism, Symbolism, Decadence and Art Nouveau as the great enemies, evidence of the need for a cleansing of Western culture, and a host of writers and artists, including Whistler and Wilde, Verlaine, Mallarmé and Rodin, as their most recalcitrant representatives. Especially the latter-named, the signs of whose degeneracy were discovered by Nordau not only in their work but in their very appearance, in their stigmata: in the mongolism of the one and in the pointed satyr's ears of the other, etc, etc. 'If this organic deficiency appears in a man of the lower classes,' Nordau wrote, 'he becomes a vagabond; in a woman of that class it leads to prostitution; in one belonging to the upper classes it takes the form of artistic and literary drivel.'[88] Nordau's cultural and artistic biological evolutionism is encapsulated in two books: one is *Von Kunst und Künstlern* (On Art and Artists);[89] the other, as we well know, is entitled simply *Entartung* (Degeneration). According to Nordau's theories, one of the most malignant forms of degeneration affecting *fin de siècle* art—predictably, the same one hated by Loos—was what he calls erotomania: in other words, the libidinous interpretation of all that is visible. *Eros* may be the darkest and most unconscious origin of art, but modern man—superior, able to control his sexual impulses and directed towards the highest spiritual goals—should have banished it, because, inevitably and unarguably, that moral and aesthetic baseness is rooted in physical degeneration: it develops, Nordau says, in those individuals in whom the parts of the brain and spinal cord containing the sexual nerve centres present malformations, which, moreover, are very rarely accidental, and almost always hereditary.

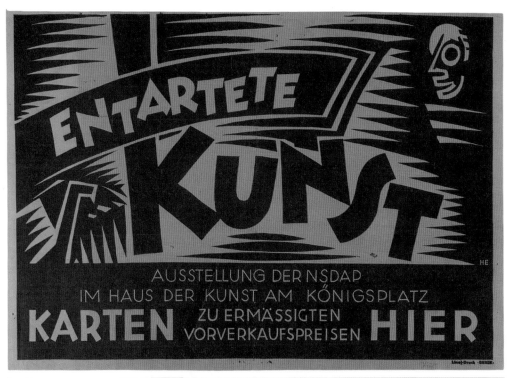

fig. 52

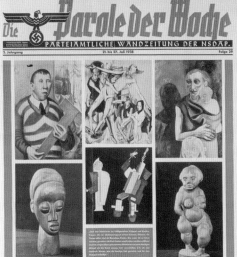

fig. 53

For Nordau, the degenerate, biologically dominant, is destined to engender yet more degenerates, and not only are tattoos and the taste for ornament pathological signs of decadence, but physical malformation too, visible or not, is a sort of genetic ornament. The descendents of inferior beings, the primitive, the diseased or the criminal will be even baser beings, just as the heritage of all those *fin de siècle* intellectuals could only be a decadent culture, morally associated with deformity, crime and barbarism.

Prevention and cleansing are the solutions offered by these authors, a *nettoyage* that takes a multiplicity of forms, all well known in an age such as ours, so accustomed to despoliation and horror on a massive scale: the control of migration and marriage, segregation, deportation, internment camps, eugenics ... The concept, if we can so call it, of 'degenerate art'—which, with all its physical, moral and racial implications, was a very important part of the cultural propaganda of Nazism and considered worthy of a major exhibition entitled precisely *Entartete 'Kunst'* (Degenerate 'Art')—with the word Art in quotes—comes directly from these theories [fig. 52-55]. It is instructive to note here the way Nordau recalls one of the first exhibitions of the Pre-Raphaelite Brotherhood in London in 1849. The result, he says, 'was crushing': 'Hitherto no hysterical fanatic had tyrannically forced on the public a belief in the beauty of these works, nor was it as yet under the domination of [...] fashion [...] Hence it [...] found them incomprehensible and funny. The contemplation of them,' Nordau continues, 'roused inextinguishable laughter among the good-humoured [...].'[90] Leaving aside for a moment the familiar instances of spectators responding with laughter to the first expressions of modern art—the case of Manet's *Olympia* is, thanks to Bataille, the most famous, but the reaction has been repeated time and again—what we see in photographs of the *Entartete 'Kunst'* exhibition are 'good-humoured' people—Hitler, Goering [fig. 55] and other high-ranking Nazis at the official opening, and large crowds [fig. 54] everywhere the exhibition was put on—always facing the camera and laughing (the fashion of laughing in photographs was very recent)[91], pointing a finger or a stick at the works of leading avant-garde artists, as degenerate as they are, in effect, ridiculous. Nordau says that the visitors to the Pre-Raphaelite exhibition laughed because they had 'not yet been prepared': when the chief theoreticians of 'degenerate art' organized their books as 'dialectical montages' in which reproductions of avant-garde paintings and sculptures were compared with medical photographs of the mentally ill and the crippled, they were not simply taking the theory of degenerate art to its ultimate conclusion, the claim that the principal ornamental production of the degenerate are their own stigmas, but in truth, quite didactically, what they were doing, at the end of a whole cycle, was *un-preparing* the public [fig. 56-58].[92]

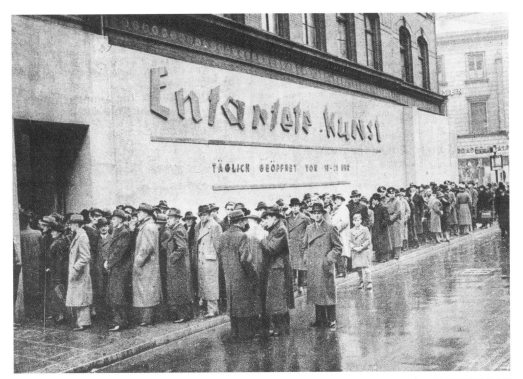

fig. 54

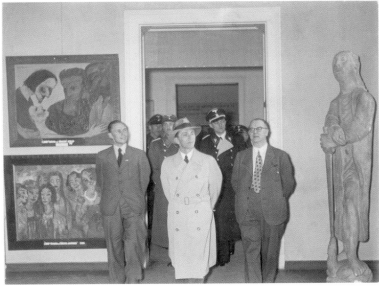

fig. 55

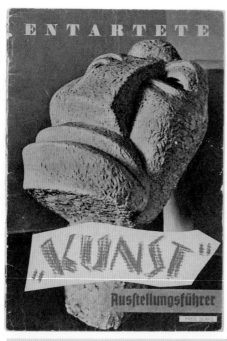

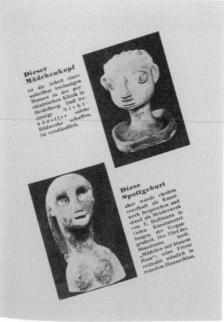

fig. 56

Ausdruck sucht. Allein, das, was in den letzten Jahrzehnten in Deutsch-
land von einer neuen Kunst redete, hat die neue deutsche Zeit jeden-
falls nicht begriffen. Denn nicht Literaten sind die Gestalter einer
neuen Epoche, sondern die Kämpfer, d. h. die wirklich gestaltenden
völkerführenden und damit Geschichte machenden Erscheinungen. Dazu
werden sich aber diese armseligen verworrenen Pinsler oder Skribenten
wohl kaum rechnen.

Außerdem ist es entweder eine unverstorene Frechheit oder eine
schwer begreifliche Dummheit, ausgerechnet unserer heutigen Zeit
Werke vorzusetzen, die vielleicht vor zehn- oder zwanzigtausend Jahren
von einem Steinzeitler hätten gemacht werden können. Sie reden von
einer Primitivität der Kunst, und sie vergessen dabei ganz, daß es
nicht die Aufgabe der Kunst ist, sich von der Entwicklung eines Volkes
nach rückwärts zu entfernen, sondern daß es nur ihre Aufgabe sein
kann, diese lebendige Entwicklung zu symbolisieren.

Die heutige neue Zeit arbeitet an einem neuen Menschentyp.
Ungeheure Anstrengungen werden auf unzähligen Gebieten des Lebens
vollbracht, um das Volk zu heben, um unsere Männer, Knaben und
Jünglinge, die Mädchen und Frauen gesünder und damit kraftvoller
und schöner zu gestalten. Und aus dieser Kraft und aus dieser Schön-
heit strömen ein neues Lebensgefühl, eine neue Lebensfreude. Niemals
war die Menschheit im Aussehen und in ihrer Empfindung der
Antike näher als heute. Sport-, Wett- und Kampfspiele stählen
Millionen jugendlicher Körper und zeigen sie uns nun steigend in
einer Form und Verfassung, wie sie vielleicht tausend Jahre lang
nicht gesehen, ja kaum geahnt worden sind. Ein leuchtend schöner
Menschentyp wächst heran, der nach höchster Arbeitsleistung dem
schönen alten Spruch huldigt: Saure Wochen, aber frohe Feste.
Dieser Menschentyp, den wir erst im vergangenen Jahr in den
Olympischen Spielen in seiner strahlenden stolzen körperlichen Kraft
und Gesundheit vor der ganzen Welt in Erscheinung treten sahen,
dieser Menschentyp, meine Herren prähistorischen Kunststotterer, ist
der Typ der neuen Zeit. Und was fabrizieren Sie? Mißgestaltete
Krüppel und Kretins, Frauen, die nur abschreckend wirken können,
Männer, die Tieren näher sind als Menschen, Kinder, die, wenn

26

Dieser Mädchenkopf ist die Arbeit eines
unheilbar irrsinnigen Mannes in der psy-
chiatrischen Klinik in Heidelberg. Daß irr-
sinnige Nicht-künstler solche Bildwerke schaffen,
ist verständlich.

Diese Spottgeburt aber wurde ehedem
ernsthaft als Kunst-werk besprochen und
stand als Meisterwerk von E. Hoffmann
von vielen Kunstaus-stellungen der Vergan-
genheit. Der Titel des Monstrums hieß:
"Mädchen mit blauem Haar", seine Frisur
erstrahlt nämlich in reinstem Himmelblau.

verworfener ist als die Prostituierte. Kurzum: Das moralische Programm des Bolschewismus schreit in dieser Abteilung von allen Wänden.

Gruppe 6.

Hier wird an einer größeren Zahl von Werken sichtbar gemacht, daß sich die entartete Kunst vielfach auch in den Dienst jenes Teiles der marxistischen und bolschewistischen Ideologie gestellt hat, deren Ziel lautet: Planmäßige Abtötung der letzten Reste jedes Rassebewußtseins. Wurde in den Bildern der vorigen Abteilung die Dirne als sittliches Ideal hingestellt, so begegnen wir nun hier den Neger und Südsee-insulaner als dem offensichtlichen rassischen Ideal der „modernen Kunst". Es ist kaum zu glauben, daß die Macher

Und was fabrizieren sie? Mißgestaltete Krüppel und Kretins, Frauen, die nur abscheuerregend wirken können, Männer, die Tieren näher sind als Menschen, Kinder, die, wenn sie so leben würden, geradezu als Fluch Gottes empfunden werden müßten! Und das wagen diese grausamsten Dilettanten unserer heutigen Mitwelt als die Kunst unserer Zeit vorzustellen, d. h. als den Ausdruck dessen, was die heutige Zeit gestaltet und ihr den Stempel aufprägt.

Der Führer
bei der Eröffnung des Hauses der Deutschen Kunst
über die Träger des Kunstverfalles.

16

Die Dirne wird zum sittlichen Ideal erhoben!

Was die bolschewistische Jüdin Rosa Luxemburg an der russischen Literatur besonders liebt: „Die russische Literatur adelt die Prostituierte, verschafft ihr Genugtuung für das an ihr begangene Verbrechen der Gesellschaft..., erhebt sie aus dem Fegefeuer der Korruption und ihrer seelischen Qualen in die Höhe sittlicher Reinheit und weiblichen Heldentums."

Rosa Luxemburg in „Die Aktion" 1921.

Zur Gliederung der Ausstellung

Da die Fülle der verschiedenen Entartungserscheinungen, wie sie die Ausstellung zeigen will, auf jeden Besucher ohnehin einen fast niederschmetternden Eindruck macht, wurde durch eine übersichtliche Gliederung dafür gesorgt, daß in den einzelnen Räumen jeweils der Tendenz und der Form nach zusammengehörige Werke in Gruppen übersichtlich vereinigt sind. Nachstehend wird die Führungslinie kurz dargestellt.

Gruppe 1.

Hier ist eine allgemeine Übersicht über die Barbarei der Darstellung vom handwerklichen Standpunkt her zu gewinnen. Man sieht in dieser Gruppe die fortschreitende Zersetzung des Form- und Farbempfindens, die bewußte Verachtung aller handwerklichen Grundlagen der bildenden Kunst, die grelle Farbkleckserei neben der bewußten Verzerrung der Zeich-

Wer nur das Neue sucht um des Neuen willen, verirrt sich nur zu leicht in das Gebiet der Narreteien, da das Dümmste, in Stein und Material ausgeführt, natürlich um so leichter das wirklich Neuartigste zu sein vermag, ja ja in früheren Zeitaltern jedem Narren genehmigt wurde, die Umwelt durch die Ausgeburten seines kranken Hirns zu beleidigen.

Der Führer
Reichsparteitag 1933.

6

Ein sehr aufschlußreicher

rassischer Querschnitt

Man beachte besonders auch die unten stehenden drei Malerbildnisse. Es sind von links nach rechts: Der Maler Morgner, gesehen von sich selbst. Der Maler Radziwill, gesehen von Otto Dix. Der Maler Schlemmer, gesehen von E. L. Kirchner.

fig. 57

Schmidt-Rottluff, den die jüdische Literaten-Clique eines „Bahnbrecher der modernen Kunst" nannte, „ideal" Frauenbildnisse dieser Art — und Dutzende von gesinnungsgleichen Kunstsammlern taten es ihm gleich. Der einst einflußreiche Kunstliterat Grohmann erklärt, seine Werke seien das „Ethos einer schöpferischen Tat".

46

Adolf Ziegler: Studienkopf Hertha

47

Genau so entartet wie die Malerei war auch die Plastik. Nur mißgestaltete Dinge wurden dem Volk als „Kunstwerke" vorgesetzt.

Hrn. Paul Simon: Knabenkopf

Oben: Hoffmann: Mädchen mit blauen Haar. Die Plastik ist noch mit blauer Farbe abschreckender bemalt als irgendein Götze der Fidschi-Insulaner.
Früher: Städt. Museum Dresden. Ankaufspreis 500 RM.

Unten: Freundlich: Kleiner Kopf aus Gips (— etwa der des Bildhauers selbst? —) angekauft von der Kunsthalle Hamburg.

Max Bezner: Knabenbüste

76

77

Ein wirres, sinnloses Durcheinander, von keiner Phantasie deutbar, bezeichnet der „Künstler" Molzahn als den „Gott der Flieger". Wer diese Ausgeburt einer Geistesstörung nicht für Kunst hielt, mußte sich durch den Leiter der Staatlichen Kunstsammlung in Dresden, Dr. D. F. Schmidt, wie folgt belehren lassen:
„Molzahns Kunst, so jung sie ist, ist nicht mehr fortzudenken aus dem Bilde dessen, was wir hoffend Kultur der Zukunft nennen."

Früher: Folkwang-Museum Essen.

Ferdinand Spiegel: Der Flieger

40

41

Kunst und Raſſe
Von Paul Schultze-Naumburg

fig. 58

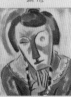

Abb. 118. Abb. 119.

Abb. 120. Abb. 121.

Die Abb. 118—121, 126—128, 132—134, 135—139 und 142—145 ſind Ausſchnitte aus Bildern der „modernen“ Schule, die beſonders bezeichnende Geſtalten darſtellen. Die ihnen gegenüberſtehenden Abb. 122—125, 129—131, 135—137, 140—141 und 146—149 zeigen körperliche und geiſtige Gebrechen aus der Sammlung einer Klinik.

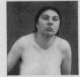

Abb. 122. Paralyſe, 123 Mongoloide Idiotopie. 124. Lähmung der Augenbewegungsnerven, 125. Mikrozephalie. Ptoſis

überſtellung nicht darin, jeweils eine getreue Übereinſtimmung zu finden, ſondern eine Wirklichkeit zu zeigen, die den Vorſtellungen jener Bilder ungefähr entſpricht.

Neben dem Grauen vor etwas unausſprechlich Widerlichem wird den ſeeliſch und körperlich gerade gewachſenen Menſchen ja auch ein tiefes Mitleid für jene Armſten der Armen ergreifen. Die Macht des Helfenwollens ſcheint hier aber zur Ohnmacht verdammt; um ſo ſtärker

Abb. 126.
Abb. 128.
Abb. 126–128. Ausschnitte aus Bildern der „modernen" Schule

wird bei dem Menschenfreund in jeder Form das Ziel erscheinen: mit allen Mitteln der menschlichen Intelligenz daran zu arbeiten, daß die Zahl der grausam Betroffenen und vor allem der so furchtbar erblich Belasteten kleiner werde, dafür zu sorgen, daß solche Unglücklichen überhaupt nicht geboren werden und so vielleicht diese Leiden langsam verschwinden.

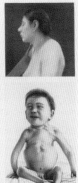

Abb. 129. Elephantiasis. Abb. 130. Mikrozephalie. Abb. 131. Rachitis

Was hat es aber für unser Volksleben zu sagen, daß eine gewisse Schicht sich künstlerisch so ausdrückt und ein weit größerer Teil es hinnimmt und wie jede andere Mode anbetet?

Es ist für einen denkenden Menschen schwer, nicht nach der Ursache dieser Erscheinungen zu fragen, die sich aufdringlich genug innerhalb eines Volkes zeigen, das bisher als vorwiegend nordisch eingestellt

Abb. 142.
Abb. 143

Abb. 144.
Abb. 145.
Abb. 142–145 sind Ausschnitte aus Bildern der „modernen" Schule

Abb. 146. Gelenkveränderung nach Tabes
Abb. 147. Endemischer Kretinismus
Abb. 148. Meningoenzephalitis (Grippe) mit Kiefer (Maskulinefazies)
Abb. 149. Mongoloide Idiotie

Loos's titles, too—'Ornament und Verbrechen' (Ornament and Crime), 'Die Überflussigen' (The Superfluous), 'Kultur' (Culture) and 'Kulturentartung' (Cultural Degeneration)—derive directly from Nordau's theories and ride on the back of their popularity. Indeed, not just the titles, but the examples and arguments too. But let's not be naïve, and let's not overreact. God forbid that we should try to establish direct links between such commonplaces. It is true that Loos was tenderly paternalistic towards children who scribbled on the walls, and 'tolerated', as he says, shoemakers who decorated shoes, or Kaffirs, Papuans, Persians and Slovak peasant women, who didn't know any better. But we do not live in limbo. When Loos, who wrote that he was speaking only to superior men, to the aristocrats—'I am preaching to the aristocrats; I mean, to the people in the forefront of humanity'—exclaimed cheerfully that 'if someone who is tattooed dies in freedom, then he does so a few years before he would have committed murder',[93] what was he actually saying?

However, it seems that history has a taste for revenge. In 1898, in 'Englische auf der Kunst Schulbank' (English Art at the School Desk),[94] Loos wrote: 'No invertebrate animal can divert the orangutan from its path towards man.' Years later, in 1929, in the entry on 'Architecture' in the 'Dictionnaire critique' (Critical Dictionary) in *Documents*, which as we know advocates 'bestial monstrosity' as the only salvation from the 'architectural scum', Bataille radically corrected this theory, taking it to the limit, 'Man,' he wrote, 'is an intermediate link in the evolution from ape to architecture.'[95] And yet another parallel: in the second issue of *Das Andere*, in 1903, Loos published a photograph of a shop in Vienna [fig. 59], paying tribute to its front, which 'dates from those times when Vienna was still at the heart of Western culture, when there was no difference between British and Austrian shopfronts'.[96] We suddenly realize that the shop is about to be demolished. What does Loos propose? To move it to the municipal museum. What he does not say is that this is a butcher's shop, and nor does he mention the carcase in front of it, hanging on a hook and lieing on the pavement in a perfectly orthogonal composition like the woodwork of the shopfront.

Bataille also wrote many years later an entry for 'Abbatoir' (Slaughterhouse), for the same 'Dictionnaire critique' [fig. 60]: this was the site of a cursed architecture, like that of the factory chimneys.[97] The now famous photographs by Eli Lotar that accompany this article, taken at the slaughterhouses in La Villette, show hacked-off cows' hooves lined up like showgirls' legs—the ornament of the masses, according to Krakauer[98]—in a precise rhythm on the perfect orthogonality of the corner, set up a haunting resonance with the Loos photograph, one of the few he published.

fig. 59

von der Arbeit verstehen würde wie Sie, dann hätte ich auch Ihre Phantasie!

Und lebt nun glücklich und zufrieden.

Und macht Sättel. Moderne? Er weiß es nicht. —

Sättel.

———

AHA, wird der Leser sagen, der das nebenstehende Bild betrachtet, das ist so ein englischer Laden in einer alten englischen Stadt. In Chester oder in Stratford on Avon. Wie aus einem alten englischen Blatte herausgeschnitten.

Der Leser irrt sich. Das ist eine Wiener Aufnahme, aus dem Herzen der Stadt. Am Wildpretmarkt befindet sich dieses Portal, das letzte Wiener Portal aus dem alten Wien. Es stammt aus einer Zeit, in der Österreich noch im Herzen des abendländischen Kulturbezirkes lag, aus der Zeit, in der es keine Unterschiede zwischen englischen und österreichischen Portalen, zwischen englischen und österreichischen Möbeln und Tischlererzeugnissen gab. Aus der Kongreßzeit. Aus der Zeit, die fast hundert Jahre zurück liegt, in denen alle Faktoren daran gearbeitet haben, uns langsam, aber sicher zu Balkanstaatlern herunterzudrücken.

Ich weiß, was mir die gelernten Archäologen und Architekten zurufen werden. Sie werden sagen: Das ist falsch. Denn zwischen den englischen Möbeln und den österreichischen vom Jahre 1815 besteht wohl ein Unterschied.

Das räume ich ein. Aber der Unterschied war nicht größer als der zwischen einem Frack von Frank und einem von Poole. Der Laie erkennt ihn nicht. Der Schneider wird ihn sofort heraushaben.

Ehre der Familie Exinger, die durch 90 Jahre ihr Geschäftsportal in dem gleichen Zustande erhalten hat! Wohl wurde es fast alle zehn Jahre neu gestrichen. Aber man hat immer die ursprünglichen Farben, weiß und grün, gewählt, obwohl man schon durch 50 Jahre in Wien den Versuch macht, uns durch den Anstrich Eichenholz oder Nuß, und jetzt — man sieht, es gibt einen Fortschritt — Ahorn oder Mahagoni vorzuschwindeln. Ehre der Familie Exinger! Ihrer Treue, ihrem Festhalten an der wahren österreichischen Kultur haben wir es zu verdanken, daß wir uns heute noch an der ursprünglichen Gestalt und Farbe des Portales erfreuen können.

Aber nicht lange mehr. Denn in 14 Tagen, am 1. November, wird mit dem Abbruch des Hauses begonnen. Und das gibt mir eine Idee. Sie ist nicht von mir. Als die Großmarkthallen in Berlin erbaut wurden, wurde die letzte Berliner

In the same 'Dictionnaire critique', in the entry for 'Musée',[99] Bataille wrote that in the museum the building and the exhibits are the container, with the real content being the public. In that respect, museums and fairs are not much different, if at all. Those are the places where the crowds learn to discover themselves in their own spectacle.

History takes its revenge, indeed. Loos proposed that the Exinger butcher's shop, instead of being demolished, should be dismantled and moved from its original location to the Museum of the City of Vienna, to be exhibited there, and that is where it ended up in the 1960s, and also on show there is the frozen reconstruction of the once warm and cosy fireplace corner of Loos's own apartment. The abattoirs of La Villette, meanwhile, have long since been buried under layer upon layer of architecture.

———————

But I would not want to end this essay on Loos on a melancholy note. It is worth asking, and more than one writer has already done so, whether the ideas Loos puts forward in 'Ornament und Verbrechen' are 'consistent' with his architecture, and especially with the house on Michaelerplatz [fig. 62], for which the publication of that article was so useful as justification and propaganda. The answer is 'no'. There is no coherence, simply because—mut we repeat it?—'Ornament und Verbrechen' says nothing about architecture. It is consistent, however, and absolutely so, with the 'classical' tradition that Loos, as we have seen, claimed for himself: that of Schinkel and Semper, that of the 'old people of the Cinquecento', that of Rome. I will not dwell on this, or refer to the more generic issues, such as the tripartite organization of the façade and the sharing out of materials—highly veined marble on the socle with a complex articulation of columns, pillars and undulating walls; smooth white stucco on the upper floors, with a homogeneous distribution of the windows; a wide frieze, indicated by a thin moulding and wide cornice at the crown—which have so much to do with the atmospheric organization of the palaces of a certain German and Austrian Baroque that Loos, presumably, knew well. He would have had to start from there, but that much is obvious.

fig. 60

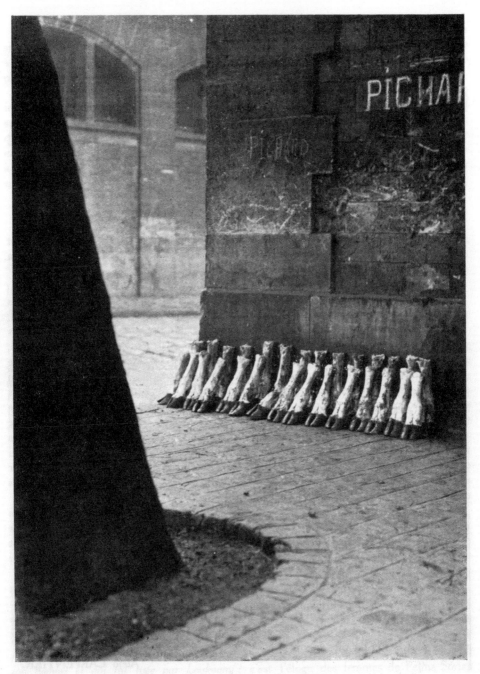

Aux abattoirs de La Villette. — Photo. Eli Lotar.

I would rather dwell on one or two small details. In 'Mein Haus am Michaeler-platz' (My house on Michaelerplatz)[100], a lecture he gave in 1911 [fig. 61], Loos talks about the organization of the façade and reveals some of the mechanisms of its composition. He mentions, for example, being proud that 'the axes of the windows on the ground floor and mezzanine do not correspond with those on the residential upper floors', and also that the windows of the mezzanine, 'angled out-wards 45 degrees, divided into equal parts, confuse the eye seeking to determine their axes'. Well, then, let's follow the order Loos proposes, albeit looking only at the main façade [fig. 64]. On the ground floor, four Doric columns divide the space into five openings: their shafts of highly veined green marble stand out as plastic forms, imposing and isolated, against the shade of the shop windows, displaying a rhythm that contracts in the narrower openings at either end; above, on the mez-zanine, much lower in height, the pillars on the axes of the columns follow the same rhythm, but this now alternates with the embrasures of the bow windows, the central part of which, flush with the plane of the pillars, framed by the shadows of the faces at 45 degrees, introduces a rhythm and an articulation of light and shade that are far more complex: pillar of veined marble, shaded void of the same width, glass surface of double that width, and then starting again; finally, the first row of windows on the volume of residential upper floors rests on the cornice with its simple rhythm of solid and void, and with the vertical axes effectively displaced in relation to those coming up from the socle. As the author of such a complex and beautiful solution—of 'such daring', in his own words—Loos had good reason to be proud. Brimming with pride, then, he recounts the anecdote of Bruckner's warning to his harmony students: 'And now I refer to the greatest mistake that can be committed in music. It is this and this. Let no one make it. It is the most horrible thing. This error appears on only two occasions in the history of music: in a certain Beethoven sonata and in my Second Symphony.' Well: in the history of architecture, when and where do we find similar 'mistakes', similar compositional refinements? In one place: the Pantheon. In the house on Michaelerplatz Loos is, in effect, eminently interpreting the very complex compositional structure of the Roman interior [fig. 63, 64, 67, 68]: the ground floor, with the Corinthian columns lit up and standing out against the darkness of the deep niches, alternating solemnly with the rotundas; the attic, its windows coinciding with the central axes of the rotundas and niches, but framed by the rapid rhythm of the four small intermedi-ate pilasters, very close together, whose axes do not coincide with anything; and, finally, the first row of large square caissons excised from the concrete of the dome, whose ribs do not match the axes of the pilasters. Like the Pantheon, Loos's house is composed of three differently articulated horizontal bands—the lowest solemn,

fig. 61

fig. 62

fig. 63

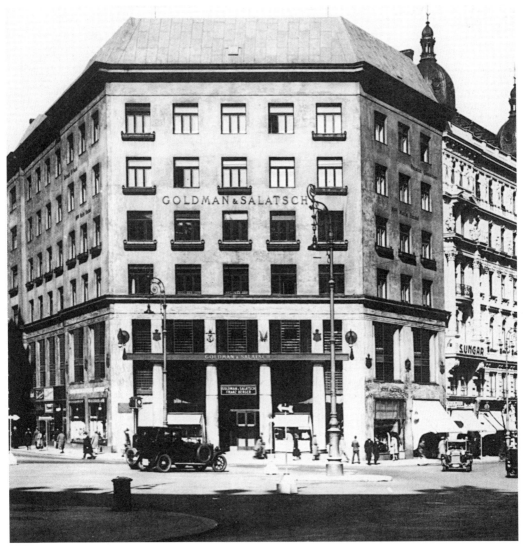

fig. 64

with large openings and magnificent columns manifesting themselves in all their plastic determination; the intermediate band of the attic nervous, with a rapid staccato rhythm, achieved with almost miniaturized components; and the last, with its windows or caissons, elementary, based on the grid—whose vertical axes, and this is the most striking thing, do not match, as if there had been some kind of slippage between these bands, although in reality the linkage they would seem to propose is impossible [fig. 67]. The Renaissance architects who spent so much time drawing the Pantheon—those 'old people of the Cinquecento'—systematically tried to correct that Roman 'error'. Not so Raphael, who depicted the interior of the Pantheon in a wonderful drawing [fig. 68] that insists precisely on what he was almost alone in seeing and trying to understand, and who in some of his works—in the palace he painted in *The Fire in the Borgo* [fig. 66] (which is a critique of Bramante's Palazzo Caprini [fig. 69] in particular and of all normative interpretation of antiquity in general), in the Palazzo Branconio [fig. 70] or in Villa Madama [fig. 65]—followed that example in the most varied and fruitful way.

Loos could say, then, with Bruckner, that that 'error' of composition—the bands with their diverse articulation and displaced axes—was only, or almost only found in the Pantheon, in Raphael's palaces and in his Michaelerplatz house, and in so doing would be revealing the system of its true coherence. But while modern architecture has been so busy abusing 'Ornament und Verbrechen', what has it done with the beautiful Michaelerplatz house but contemplate it with more embarrassment than admiration as the as yet imperfect work of a kind of precursor of the modern? 'Loos is one of the precursors of the new spirit,' Le Corbusier declared, indeed, in *L'Esprit Nouveau* in 1921.[101] Dominated by this idea, many have wondered, in the most trivial way, what these columns are doing there, as Loos's contemporaries did. Loos himself, commenting on the criticisms directed at him, singled out those of Otto Lux: 'This pseudo-expert wrote that it should have occurred to me of all people, the defender of the absence of ornaments, to build ornamental columns.'[102] I will not examine here the somewhat convoluted way in which Loos defends his columns, claiming that they are not ornament but structure. I shall merely recall another column, built years later, in 1919: the one that stands, solitary, in the gap between the music room and the living room of the Strasser house. Of marble or of stucco, it hardly matters for the case in hand, that column, like those in the Michaelerplatz house, is magnificently veined.

fig. 65

fig. 66

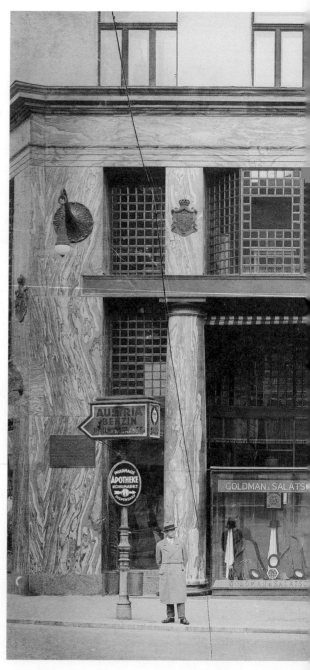

fig. 67

fig. 68

panteon

Raph. Vrbinas ex Lapide Cortij Romæ, extructum.
Antonij Laferij Romæ 1549

934.06

050

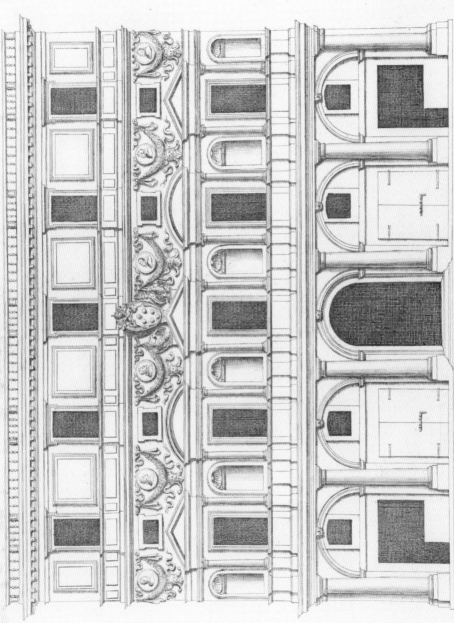

FACCIATA DEL PALAZZO ET HABBITATIONE DI RAFAELE SANTIO DA VRBINO SV LA VIA DI BORGHONOVO FABRICATO

CON SVO DISEGNO L'ANNO MD·XIII·IN Scala Diplmi Quantita

CIRCA·E·SEGVITO DA BRAMANTE DA VRBINO

15

J.Ruskin. T.S Boys

Wall Veil Decoration.

CA' TREVISAN, CA' DARIO

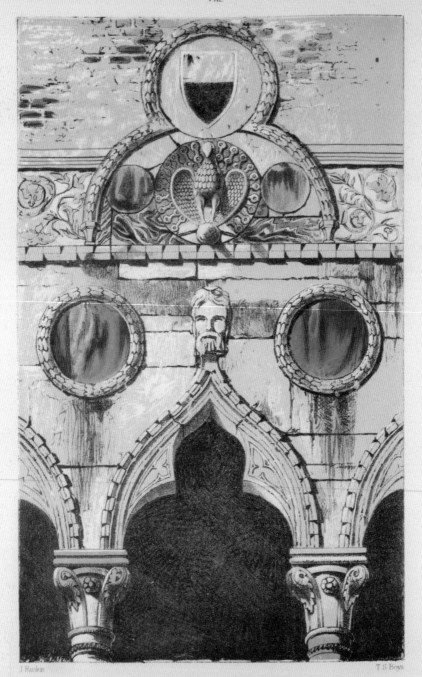

Decoration by Disks.

PALAZZO DEI BADOARI PARTECIPAZZI.

fig. 73 previous pages 69 to 72

JOHN RUSKIN

La
Bible d'Amiens

TRADUCTION, NOTES ET PRÉFACE

PAR

MARCEL PROUST

CINQUIÈME ÉDITION

PARIS
MERCVRE DE FRANCE
XXVI, RVE DE CONDÉ, XXVI

MCMX

A LA MÉMOIRE

DE

MON PÈRE

FRAPPÉ EN TRAVAILLANT LE 24 NOVEMBRE 1903

MORT LE 26 NOVEMBRE

CETTE TRADUCTION

EST TENDREMENT DÉDIÉE

M. P.

« Puis vient le temps du travail ...;
puis le temps de la mort, qui
dans les vies heureuses est très
court. »

JOHN RUSKIN.

fig. 74

How can we forget Loos's admiration, so often expressed, for simply polished granite, or his detailed account of how he chose the marbles for the Michaelerplatz house in the quarries of Euboea, or his alleged trip to the ancient Numidian onyx quarries? The richly veined marble, with a great variety of aquatic forms and colours, simply polished in a roundness balanced by the entasis—and note well that the column in the Strasser house is not only isolated, without a partner (columns are usually in pairs at least), but also without a base or a capital: it is just a shaft—constitutes in its own right an entire aesthetic category, at once visual and tactile, of a multiple and variegated beauty, far more than could be obtained by any composition. The Roman architects knew this well, especially those of the decadent Rome that interested Riegl, and so did the Byzantine architects; and so too did mediaeval architects, especially the Venetians who built San Marco. Loos visited Venice often: he knew the city well, and understood its architecture well. Would he have had under his arm the book by that character so reviled by Lombroso, by Nordau—'one of the falsest and most delinquent spirits of the century',[103] he said, among other things—and by Loos himself: John Ruskin?[104] I don't doubt it. Ruskin wrote things about these marbles that the work of Loos 'recapitulated'. Proust recalls in his preface to the French translation of *The Bible of Amiens* Ruskin's terrible words on the veined marbles of San Marco: 'Not in the wantonness of wealth, not in vain ministry to the desire of the eye or the pride of life, were those marbles hewn into transparent strength, and those arches arrayed in the colours of the iris. There is a message written in the dyes of them, that once was written in blood [...] The strength of Venice was given her, so long as she remembered this: her destruction found her when she had forgotten this.' He goes on to ask why 'the crimes of the Venetians had been more inexcusable and more severely punished than those of other men because they possessed a church of multicoloured marble instead of a limestone cathedral' [fig. 71-74].[105]

Crimes that were *more inexcusable*, then, the more they were linked to the infinite *varietas* of the veining, *virtualiter igniti*: Loos's love of material and form went beyond that *crime* that he himself, without mentioning architecture, had linked to *ornament*. What is more, Ruskin also noted with attention and love a column that stands alone, without a partner, in the transept of the old church of San Giacomo dell'Orio [fig. 75], on the Epistle side, placed there by the Venetians, according to the chronicles, from some ruined temple or, more likely, from some dismembered Byzantine building—precious spoils of war, then—which is, in contrast to the architecture of the rest of the church, in the most profound sense of the word, *pulcra*: impossible not to admire the tense entasis and the burnished *verde antico* veined marble of its monolithic shaft.

fig. 75

A solitary and perfect shaft: material, form and work of man: that is what Loos evokes in his column in the Strasser house [fig. 76], in absolute coherence with his writings — except for some: those that have made him famous and those that have mediatized him.

'Ornament und Verbrechen' has, in effect, mediatized Loos's work, and, in a more sinister sense than we might think, the whole history of modern architecture. Le Corbusier said: 'Loos swept right beneath our feet, and it was a Homeric cleansing [...] In this Loos has had a decisive influence on the destiny of architecture.' But *nettoyer* has been, in the twentieth century, a terrible verb. Loos is an overrated architect where he is valued, where the architecture has ceased to exist — and undervalued in everything else.

fig. 76

NOTES

1. *Das Andere* was published in Vienna as an offprint of Kunst: No. 1, 1 October 1903; No. 2, 15 October 1903. Now in Loos, Adolf. *Escritos I*, pp. 252-304. Madrid: El Croquis, 1993.

2. Loos, Adolf. Op. cit., p. 346 & ff.

3. Id., 'Eine Concurrenz der Stadt Wien' (A competition for the city of Vienna), *Die Zeit*, Vienna, 6 November 1897. Now in id., op. cit., pp. 16-19.

4. Id., 'Die alte und die neue Richtung in der Baukunst' (The old and new tendencies in the art of building), *Der Architekt*, 3, Vienna, 1898. Now in id., op. cit., pp. 121-127

5. Id., 'Architektur', *Der Sturm*, 15 December 1910. Now in id., *Escritos II*, pp. 28-29. Madrid: El Croquis, 1993.

6. Id., 'Otto Wagner', *Reichpost*, 13 July 1911. Now in id., op. cit., p. 42.

7. Semper, Gottifred. *Der Stil in den Technischen und Tektonischen Künsten oder Praktische Ästhetik. Vol. I: Textile Kunst für sich Betrachtet und in Beziehung zur Baukunst* (Style in the Technical and Tectonic Arts, Or, Practical Aesthetics. Vol.I: Textile Art Considered in Itself and in Relation to Architecture) Munich: Friedrich Bruckmann's Verlag, 1863 (2nd ed. 1878).

8. Loos, Adolf. 'Das Prinzip der Bekleidung' (The Principle of Cladding), *Neue Freie Presse*, Vienna, 4 September 1898. Now in id., *Escritos I*, cit., pp. 151-157.

9. Riegl, Alois. *Stilfragen. Grundlegungen zu einer Geschichte der Ornamentik* (Problems of Style: foundations for a history of ornament). Berlin: G. Siemens, 1893. I quote from the Spanish translation. Id., *Problemas de estilo. Fundamentos para una historia de la ornamentación*, p. 4. Barcelona: Gustavo Gili, 1980.

10. Loos, Adolf. 'Glas und Ton', (Glass and China) *Neue Freie Presse*, Vienna, 26 June 1898. Now in id., op. cit., pp. 82-88.

11. Id., 'Weinachtsausstellung im Österreichischen Museum' (Christmas Exhibition of the Austrian Museum), *Die Zeit*, Vienna, 18 December 1897. Now in id., op. cit., p. 27.

12. Id., 'Das Sitzmöbel' (Furniture for Sitting), *Neue Freie Presse*, Vienna, 19 June 1898. Now in id., op. cit., p. 76.

13. Riegl, Alois. Op. cit., p. 7.

14. Loos, Adolf. 'Das Luxusfuhrwerk', *Neue Freie Presse*, Vienna, 3 July 1898. Now in id., op. cit., pp. 89-95.

15. Id., *Trotzdem 1900-1930*, (Nevertheless). Brenner, Innsbruck, 1931.

16. Darwin, Charles. *The Descent of Man*. London: John Murray, 1871. I quote from the edition published by Prometheus Books, Amherst, New York, 1998, pp. 603-605.

17. Jones, Owen. *The Grammar of Ornament*, Vol. 1, pp. 13-17 and plates 1-3. London: Bernard Quarritch, 1868.

18. Grosse, Ernst. *Die Anfänge der Kunst*. Freiburg: Akademische Verlagsbuchhandlung von J. C. B. Mohr, 1894. I have used the edition id., *The Beginnings of Art*, Appleton and Company, New York, 1897.

19. These issues are addressed in, for example, the unsigned review: 'The Earliest Art. A Learned and Interesting Work from a German Professor', *New York Times*, 5 June 1897.

20. Grosse, Ernst. Op. cit., p. 53 & ff.

21. Riegl, Alois. Op. cit., p. 21.

22. Id. pp. 14,15.

23. See note 12.

24. Loos, Adolf. 'Wanderungen durch die Winterausstellung des Österreichischen Museums' (Strolling around the Winter Exhibition in the Austrian Museum), *Neue Freie Presse*, Vienna, 11 December 1898. Now in id., op. cit., pp. 221-225.

25. Georg Simmel's essays on fashion collected in: *Philosophische Kultur* (Philosophical Culture), Klinkhardt, Leipzig, 1911. I quote from id., 'Filosofía de la moda' in *Cultura femenina y otros ensayos*, p. 144. Madrid: Revista de Occidente, 1934. See also: Veblen, Thorstein. *The Theory of the Leisure Class*. New York: The Macmillan Company, 1899; Simmel, Georg. *Philosophie des Geldes* (The Philosophy of Money).Leipzig: Duncker & Humbolt. 1900; Sombart, Werner. *Luxus und Kapitalismus* (Luxury and Capitalism). Leipzig: Duncker & Humbolt, 1913.

26. In *Das Andere*, No. 1, cit. Now in: Loos, Adolf. *Escritos I*, op. cit., p. 270.

27. Ludovici, Anthony Mario. *Nietzsche and Art*, pp. 16-17. London: Constable & Co., 1911.

28. Loos, Adolf. 'Wäsche' (Underclothes), *Neue Freie Presse*, Vienna, 23 September 1898. Now in id., op. cit., p.161.

29. Timms, Edward (ed.); Wittels, Fritz. *Freud et la femme-enfant. Mémoires de Fritz Wittels* (Freud and the Child Woman. The Memoirs of Fritz Wittels). Paris: Presses Universitaires de France, 1999, pp. 91-92.

30. See note 4.

31. Loos, Adolf. 'Die Herrenmode' (Gentlemen's fashion), *Neue Freie Presse*, Vienna, 22 May 1898; *Das Andere*, No. 2, cit. Now in id., op. cit., pp. 53-54 and 269, respectively., Note 4.

32. Id., 'Lob der Gegenwart' (In Praise of the Present), *März*, 16, Munich, 18 August 1908. Now in id., op. cit., p. 335.

33. Simmel, Georg. Op. cit., p. 164.

34. Loos, Adolf. Id., 'Architektur', cit. Now in id., *Escritos II*, cit., p. 24.

35. Pichois, Claude (Ed.); Baudelaire, Charles. 'Salon de 1859', in id., *Oeuvres Completes*, Vol. II, p. 650. Paris: Gallimard, 1976. Baudelaire recalls here the paintings of Native Americans by George Catlin, which he had seen ten years previously: id., 'Salon of 1846', op. cit., p. 446, where he also mentions the 'harmonic' tattoos. In this same 'Salon' he also writes about *Caraïbes* and modern sculpture (op. cit., p. 487), among others references to more 'savage peoples'.

36. Balzac, Honoré de. *Traité de la vie élégante* (Treatise on Elegant Living). Paris: Librairie Nouvelle, 1853. I quote from the Spanish translation, id., *Tratado de la vida elegante. Historia y fisiología de los bulevares de París*, pp. 83, 101. Madrid: Editorial América, 1911.

37. Barbey d'Aurevilly, Jules. *Du dandysme et de George Brummell* (On Dandyism and George Brummell). Caen: Mancel, 1845. 2nd ed. Paris: Librairie de Poulet-Malassis, 1861, a book dedicated, incidentally, to C. Daly, 'éditeur *de la Revue de l'Architecture*'.

38. Jesse, William. *The Life of Beau Brummell*. London: Saunders and Otley, 1844. I cite the Nimmo edition: Vol. I, p. 56. London: J. C. Nimmo, 1886.

39. This idea is developed in the next volume of the series *Columns of Smoke*, Vol. III.

40. Simmel, Georg. Op. cit., p. 156.

41. Loos, Adolf. 'Damenmode' (1898), *Dokumente der Frauen*, VI, No. 23, 1902. Now in id., *Escritos I*, cit., pp. 140-145.

42. Loos, Adolf. 'Die Herrenmode', cit.

43. Lombroso, Cesare; Ferrero, Guglielmo. *La donna delinquente. La prostituta e la donna normale*. Turin: Roux, 1894. I use *La femme criminale et la prostituée*, pp. 12 & 167-168. Paris: Alcan, 1896.

44. A. Loos,'Weinachtsausstellung im Österreichischen Museum', cit.

45. Wittels, Fritz. 'Die grosse Hetäre' 29 May 1907, now in *Minutes de la Société Psychanalytique de Vienne*

(Minutes of the Vienna Psychoanalytic Society), Vol. I, p. 215. Paris: Gallimard; id., 'Das Kindweib', *Die Fackel*, No. 230-231, Vienna, 15 July 1907, pp. 14-33. I quote from the revised version published by Wittels himself in id., 'The Childwoman', *Critique of Love*, pp. 282-313. New York: The Macaulay Company, 1929.

46. Wittels himself recalls this in *Freud et la femme enfant*, cit., p. 70. See: *Minutes de la Société Psychanalytique de Vienne*, Vol. I, cit., pp. 220-221.

47. Lombroso, Cesare; Ferrero, Guglielmo. Op. cit., p. 443.

48. Originally published in *Revue des Archives d'Anthropologie Criminel*, 1908 and 1910, now in Edel, Yves (ed.); Gatian de Clérambault, Gaëtan. *Passion érotique des étoffes chez la femme*, Paris: Les empêcheurs de penser en rond-Le Seuil, 2002.

49. Lombroso, Cesare; Ferrero, Guglielmo. Op. cit., p. 64.

50. Id., p. 210.

51. Id., p. 112.

52. Id., p. 70.

53. Id., p. 153.

54. Id., p. 150.

55. Id., p. 501.

56. Id., p. 151.

57. Id., p. 171.

58. Id., p. 172.

59. Id., pp. 169-171.

60. Id., p. 150.

61. Loos, Adolf. 'Damenmode' and 'Das Luxusfuhrwerk', cit.

62. On the question of tattoos in Loos see: Canales, Jimena; Herscher, Andrew. 'Criminal Skins: Tattoos and Modern Architecture in the Work of Adolf Loos', *Architectural History*, Vol. 48, 2005, pp. 235-256.

63. Riegl, Alois. Op. cit., pp. 55-57.

64. Lombroso, Cesare. *Palimsesti del carcere*, Turin: Bocca, 1888. I quote from id., *Les palimpsestes des prisons*, pp. 1-2. Lyon: A. Storck and Paris: G. Masson, 1894.

65. Id., op. cit., p. 40.

66. Id., p. 356.

67. Id., p. 366.

68. Id., p. 48.

69. Id., p. 362.

70. Id., p. 42.

71. In Loos, Adolf. *Escritos I*, op. cit., pp. 323-330.

72. Nordau, Max. *Entartung*. Berin: Duncker, 1892. I quote from id., *Dégénérescence*, Vol. II, pp. 535-536. Paris: Alcan, 1984.

73. Id., p. 537.

74. Id., p. 547.

75. Id., p. 551.

76. Id., p. 563.

77. Id., op. cit., Vol. I, p. V.

78. Id., op. cit., p. 67.

79. Id., op. cit., Vol. II, pp. 564-565.

80. Lombroso, Cesare. *L'uomo delinquente*. Turin: Bocca, 1878. I use the ed. of 1897, p. 658.

81. Loos, Adolf. 'Ornament und Verbrechen' (Ornament and Crime) in id., op. cit., pp. 346-355. Although it had long been thought that this essay-cum-lecture was written in 1908, as Loos himself affirmed, Christopher Long has convincingly demonstrated, among other things, that it was composed in late 1909-early 1910. See Long, Christopher. 'The Origins and Context of Adolf Loos's "Ornament and Crime"', *JSAH*, Vol. 68, No. 2, June 2009, pp. 200-223.

82. Nordau, Max. Op. cit., Vol. I, p. 33.

83. Loos, Adolf. 'Kulturentartung' (Cultural Degeneration), *März*, 15, Munich, 3 August 1908. Now in id., op. cit., pp. 332-334.

84. Klemperer, Victor. *LTI. Notizbuch eines Philologen*, Leipzig: Reclam Verlag, Leipzig, 1975. The quote is from Martin Brady's English translation: *LTI, Lingua Terii Imperii: a philologist's notebook*, p. 1. London: The Athlone Press, 2000.

85. On various aspects of these issues see: Hersey, George L. *The Evolution of Allure*. Cambridge: The MIT Press, 1996; Bindman, David. *Ape to Apollo. Aesthetics and the Idea of Race in the 18th Century*. London: Reaktion Books, 2002; Weikart, Richard. *From Darwin to Hitler*. New York, Palgrave Macmillan, 2004; González García, Ángel. *Arte y terror* (Art and Terror), Barcelona: Mudito & Co., 2008.

86. Galton, Francis. *Hereditary Genius: An Inquiry into Its Laws and Consequences*. London: Macmillan, 1869; id., *Natural Inheritance*. London, Macmillan, 1889.

87. Lombroso, Cesare. *L'uomo di genio* (The Man of Genius), Turin: Bocca, 1888. I quote from id., *L'homme de génie*, Alcan, Paris, 1889, p. 304. See too another very influential book: Réja, Marcel. *L'Art chez les fous* (The Art of the Mad). Paris: Mercure de France, 1908.

88. Nordau, Max. Op. cit., Vol. I, p. 182.

89. Nordau, Max. *Von Kunst und Künstlern. Beiträge zur Kunstgeschichte* (On Art and Artists. Contributions to the history of art). Leipzig: B. Elischer Nachfolger, 1905.

90. Nordau, Max. *Dégénérescence*, p. 126.

91. See Lahuerta, Juanjo. *Photography or Life / Popular Mies. Columns of Smoke*, Vol. I, p. 38. Barcelona: Tenov Books, 2015.

92. For example, Schultze, Paul. *Kunst und Rasse* (Art and Race). Munich: Lehmanns Verlag, 1928; Dresler, Adolf. *Deutsche Kunst und Entartete Kunst*. Munich: Deutscher Wolfsverlag, 1938.

93. Loos, Adolf. 'Ornament und Verbrechen', cit.

94. Id., 'Englische Kunst auf der Schulbank', *Wiener Runschau*, 6, Vienna, February 1898. Now in id., op. cit., pp. 231-233.

95. Bataille, George. 'Architecture'. *Documents*, No. 2, p. 117, 1929.

96. Loos, Adolf. Op. cit., p. 281.

97. Bataille, George. 'Abattoir' (Slaughterhouse), 'Cheminée d'usine' (Factory chimney), *Documents*, No. 6, p. 328-329, 1929. Both terms appear in Lahuerta, Juan José.

Op. cit., p. 56, and in *Columns of Smoke* Vol. III (in preparation).

98. See Lahuerta, Juan José. Op. cit., p. 138-139 and note 26.

99. Bataille, George. 'Musée', *Documents*, No. 5, 1930, p. 300.

100. Loos, Adolf. 'Mein Haus am Michaelerplatz', lecture, 11 December 1911. Now in id., *Escritos II*, cit., pp. 43-57.

101. Le Corbusier. (Introduction to 'Ornement et crime'), *L'Esprit Nouveau*, No. 2, Paris, November 1921, p. 159.

102. Loos, Adolf. 'Mein Haus...', cit.

103. Nordau, Max. Op. cit., Vol.I, p. 140.

104. Ruskin, John. *The Stones of Venice. With illustrations drawn by the author.* London: Smith, Elder and Co., 1851-1853, 3 vols. This was followed by a second revised edition, specifically for travellers and tourists: id., *Stones of Venice: Introductory Chapters and Local Indices (Printed Separately) for the Use of Travellers While Staying in Venice and Verona* in 2 Volumes, Orpington: George Allen, Ruskin House, 1881.

105. Proust, Marcel. 'Préface' to Ruskin, John. *La Bible d'Amiens*. Paris: Éditions du Mercure de France, 1904.

LIST OF ILLUSTRATIONS

30. Ib. 'Innenmusterung mit Spiralen, zwickelfüllendem Lotus, und Bukranien' (Interior Patterns with Spirals, Spandrel-filling Lotuses and Bucrania), p. 73.

31. Ib. 'Korinthisches Kapitäl vom Lysikrates-Denkmal' (Corinthian Capitel from the Monument of Lysicrates), p. 213.

32. Ib. 'Gravuring auf einer Fruchtschale der Maori' (Maori engraving on a fruit rind), p. 77.

33. Jones, Owen. 'Termination of the Marbles Tiles of the Parthenon', op. cit., p. 3.

34. Ib. 'Corinthian and Composite Capitals reduced from TAYLOR and CRESY's *Rome*', p. 47.

35. Ib. 'From the Choragic Monument of Lysicrates, Athens', p. 34.

36. Ib. 'Fragment of the Frieze of the Temple of the Sun, Colonna Palace, Rome', p. 45.

37. Ib. 'Title page'.

38. Ib. 'Celtic No. 2'.

39. Ib. 'Head of Canoe, New Guinea', p. 16.

40. Ib. 'Club, Eastern Archipelago', p. 17.

41. Moser, Koloman. *Ars Nova*. Vienna: Max Herzig. 1901.

Courtesy of Elisava, Escola Superior de Disseny i Enginyeria de Barcelona. Photo: Farrés, Santi.

42. Nordau, Max. *Degeneration*. Cover, title page and dedication. New York : Appleton, 1895.

43. Lombroso, Cesare. 'Tatouage symbolique d'un violateur, etc.' (Symbolic tattoo of a rapist, etc.). *L'Homme criminel* (The Criminal Man). Plate XLI. Paris: Félix Alcan, 1895.

44. Ib. 'Tatouages des camorristes Napolitains' (Tattoos of the Neapolitan Camorra), Plate XXXII.

45. Ib. 'Tatouages des prostituées' (Prostitutes' Tattoos), Plate XXXIII.

46. Ib. 'Tatouages de criminels' (Criminals' Tattoos), Plate XXXIX.

47. Ib. 'Tatouages de criminels' (Criminals' Tattoos), Plate XL.

48. Ib. 'Travaux artistiques de criminels' (Artworks by Criminals), Plate XLIV.

49. Ib. 'Céramique criminelle' (Criminal Ceramics), Plate XXXV.

50. Ib. 'Céramique criminelle' (Criminal Ceramics), Plate XXXIV.

51. Galton, Francis. 'Specimens of Composite Portraiture'. *Inquiries into Human Faculty and its Development*. London: Macmillan and Co., 1883. © Biblioteca de Catalunya.

52. Poster of the NSDAP Exhibition *Entartete Kunst* in the Haus der Kunst on Königsplatz, Munich, 1938. © Bundesarchiv, 2015.

53. 'Jewish anti-German propaganda masterminds an exhibition of "degenerate German art" in London's prestigious Burlington House.' *Die Parole der Woche*, official newspaper of the NSDAP. 21-27 July 1938. © Bundesarchiv, 2015.

54. *Entartete Kunst* Exhibition. Hamburg, 1938. © Ullstein Bild / Photoaisa, 2015.

55. Reich Minister Dr. Goebbels at the *Entartete Kunst* Exhibition. Munich, 27 February 1928. © Bundesarchiv, 2015.

56. Kaiser, Fritz. *Entartete Kunst (Degenerate Art)*. Berlin: Verlag für Kultur- und Wirtschaftswerbung, 1937.

57. Dresler, Adolf. *Deutsche Kunst und Entartete Kunst* (German Art and Degenerate Art). Munich: Deutscher Volkserlag, 1938.

58. Schultze, Paul. *Kunst und Rasse* (Art and Race). Munich: Lehmans Verlag, 1928.

59. Loos, Adolf. Das Andere, n°2, p. 2. Vienna, 1903.

60. Bataille, Georges. 'Abattoir' (Slaughterhouse). *Documents* n°6, Paris, 1929.

61. Poster announcing the lecture by Adolf Loos 'My House on Michaelerplatz'. Vienna, 1910.

62. Michaelerplatz, Vienna. Postcard, c. 1910.

63. Interior of the Pantheon with the fragment of the attic restored to its original state. © Compass and Camera, Istock by Getty Images.

64. Loos, Adolf. Michaelerplatz, 3. 1910.

65. Raphael. Villa Madama, Rome, 1519. Photo c. 1927.

66. Raphael. *The Fire in the Borgo* (detail), Vatican City, 1514.

67. Business premises of Goldman & Salatsch, Vienna I. Michaelerplatz 3, Michaelerplatz Portal, 1909/11. Photo: Gerlach, Martin. © Albertina, Vienna.

68. Raphael (attributed to). *Interior view of the Pantheon.* Inv. H193/2. © University Library of Salzburg.

69. Palazzo Caprini. Lafréry, Antonio. *Speculum Romanae Magnificentiae.* (Magnificent Looking-glasses of Rome) Rome, 1575. Courtesy of the Herzog August Bibliothek.

70. Branconio Palace. Ferreiro, Pietro. *Palazzi di Roma de piu celebri architetti* (Palaces of Rome by the Most Celebrated Architects). Rome, 1655. Courtesy of the Col·legi d'Arquitectes de Catalunya. Photo: Suñé, Alba.

71. Ruskin, John. 'Wall Veil Decoration'. *The Stones of Venice. With illustrations drawn by the author.* Vol. I. London: Smith, Elder and Co., 1851/3 Courtesy of the Col·legi d'Arquitectes de Catalunya. Photo: Suñé, Alba.

72. Marbles in the San Marco Basilica, Venice. © Kazakov, Istock by Getty Images.

73. Ruskin, John. 'Decoration by Disks', Op. Cit.

74. Ruskin, John; Proust, Marcel (trad.). *La Bible d'Amiens* (The Bible of Amiens). Mercure: Paris, 1904. © CRAI – Biblioteca de Reserva, Universitat de Barcelona.

75. Interior of San Giacomo dell'Orio, Venice. Photo: Radomirovic, Anja.

76. Strasser house. View from the dining room into the living room and out to the bandstand, 1918/19. Photo: Riffenstein, Bruno. © Albertina, Vienna.

INDEX